In PORTRAITS I look for the unguarded moment, the essential soul peeking out, experience etched on a person's face ... When I find the right person or subject, I may come back once or twice, or half a dozen times, always waiting for that right moment. Unlike the writer, once I pack my bags, there is no chance for another draft — either I have the shot or I don't. This is what drives and haunts the professional photographer, the gnawing sense that 'this is it'.

For me, the portraits in this book speak a desire for human connection; a desire so strong that people who know they will never see me again open themselves to the camera, all in the hope that at the other end someone else will be watching – someone who will laugh or suffer with them.

From an outpouring of pictures over 20 years, these are the faces I cannot forget. Some stare out of places I don't want to remember. All of them represent chance connections in a world of resilience.

*Steve McCurry*

Φ

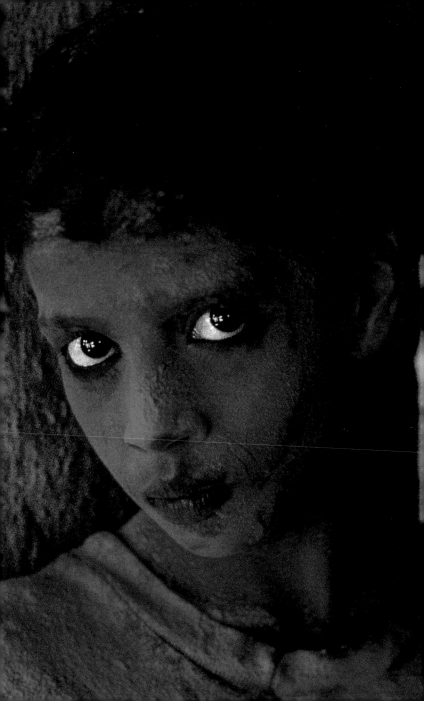

Timbuktu, Mali, 1987

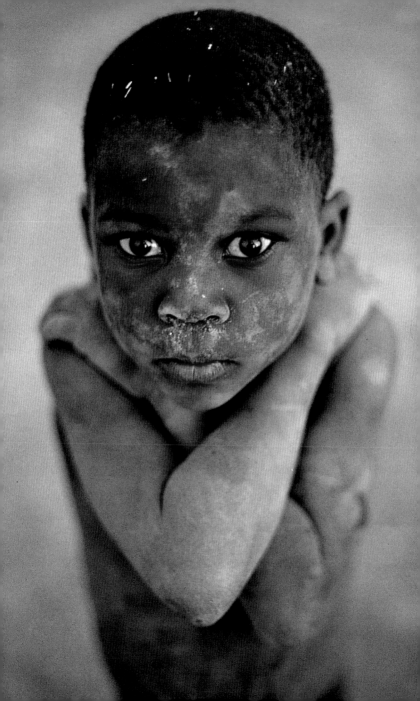

Kabul, Afghanistan, 1993

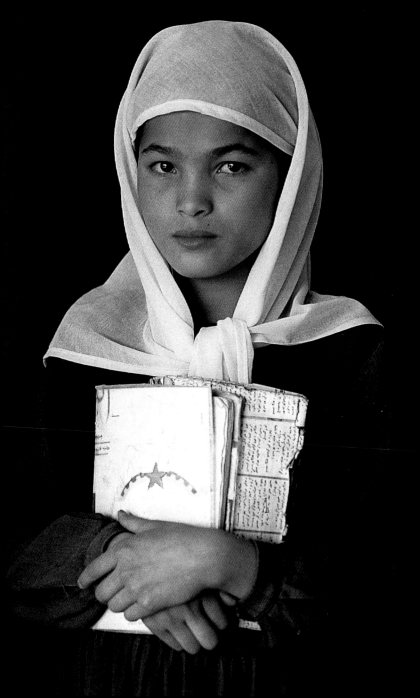

Jodhpur, India, 1997

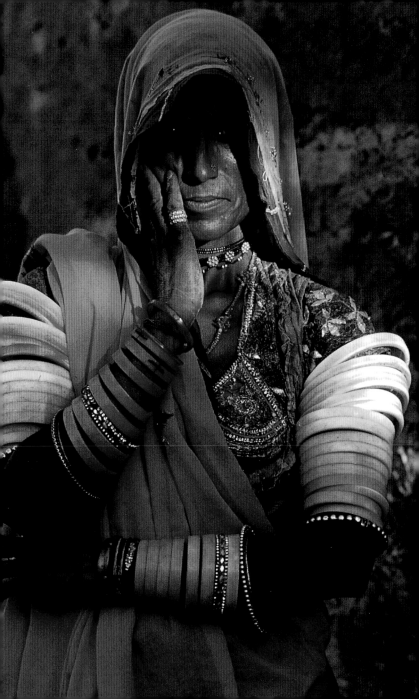

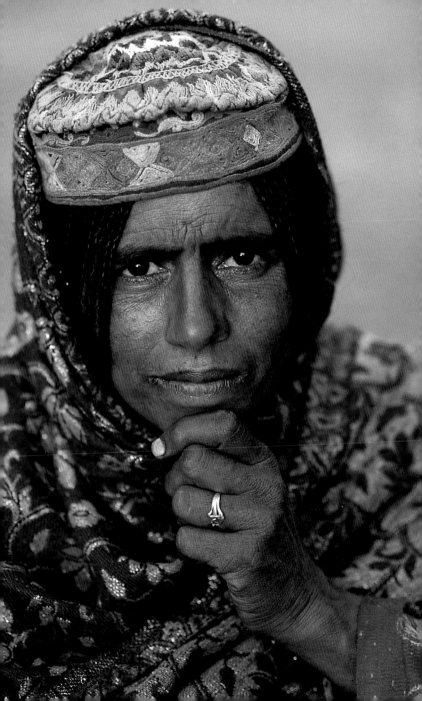

Kashmir, India, 1995

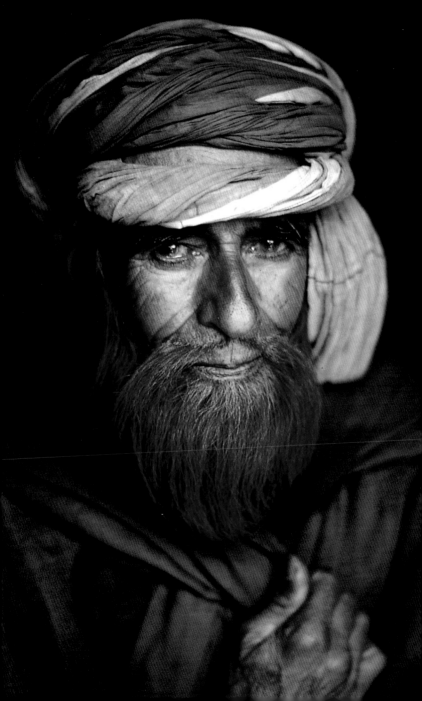

Nuristan, Afghanistan, 1990

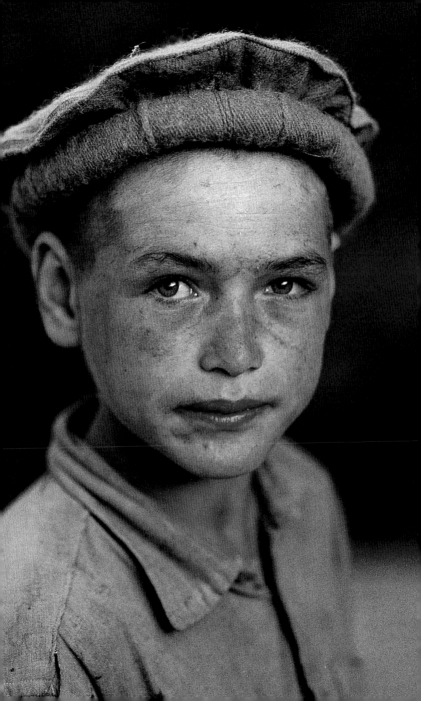

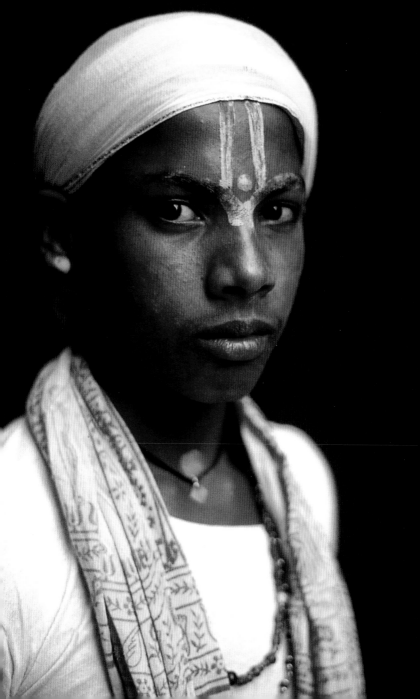

Kathmandu, Nepal, 1979

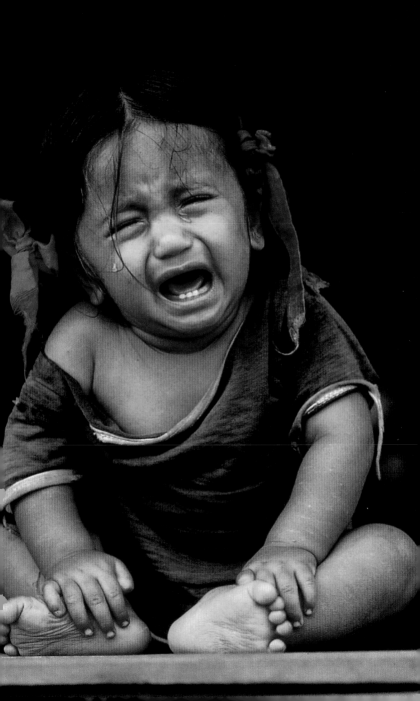

Lhasa, Tibet, 1989

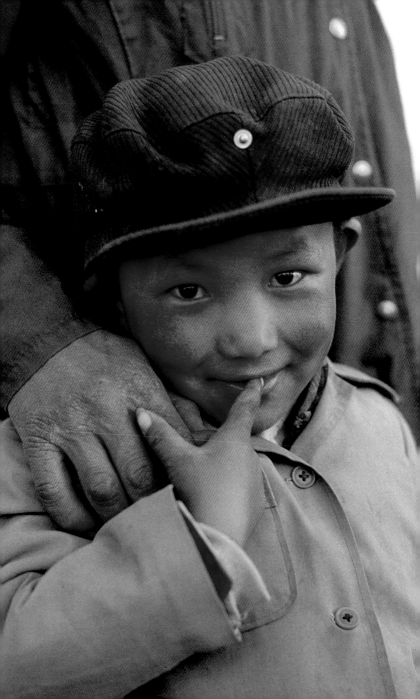

Diré, Mali, 1986

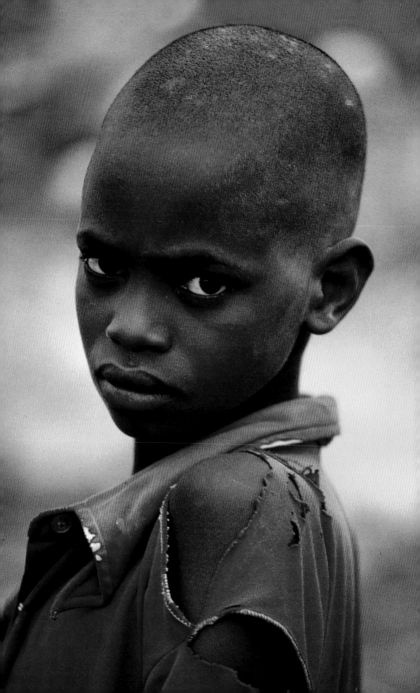

Ladakh, India, 1996

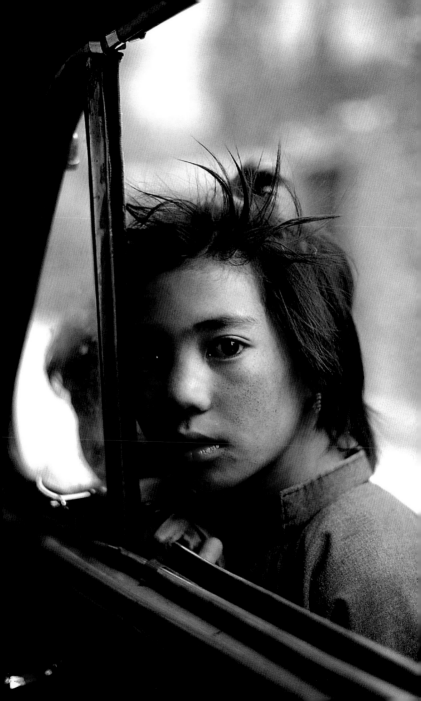

Rangoon, Burma, 1994

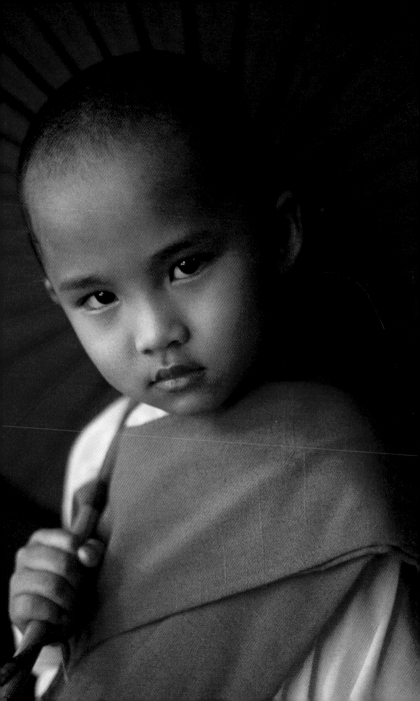

Los Angeles, USA, 1991

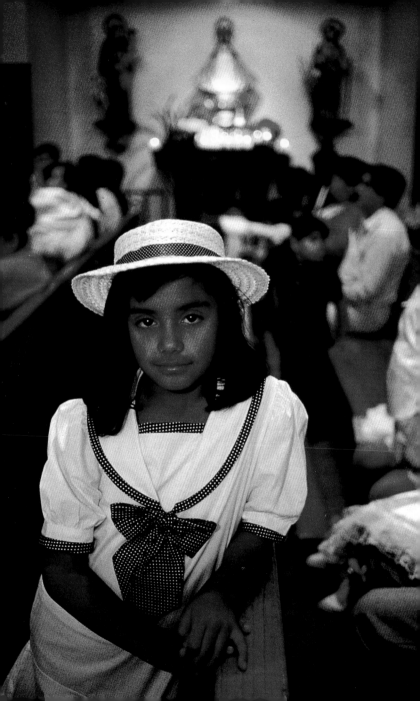

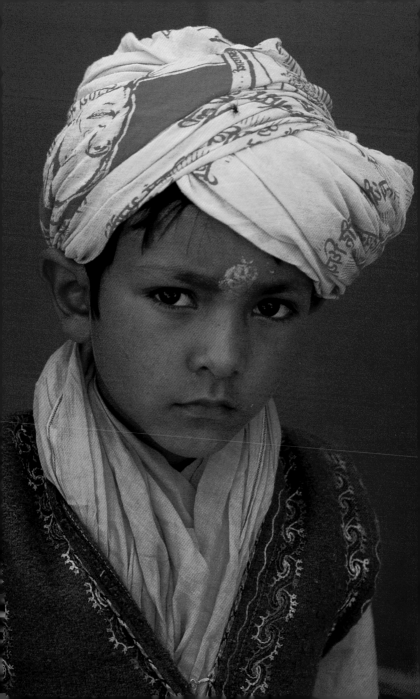

Rajasthan, India, 1996

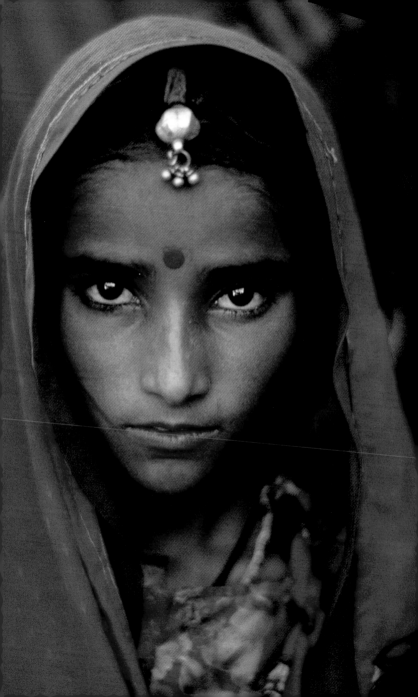

Ghazni, Afghanistan, 1990

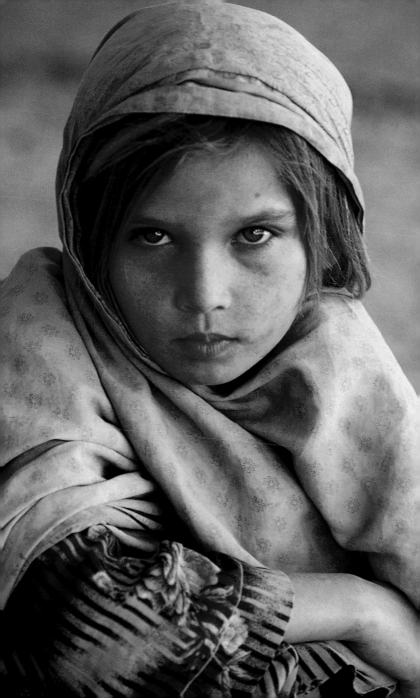

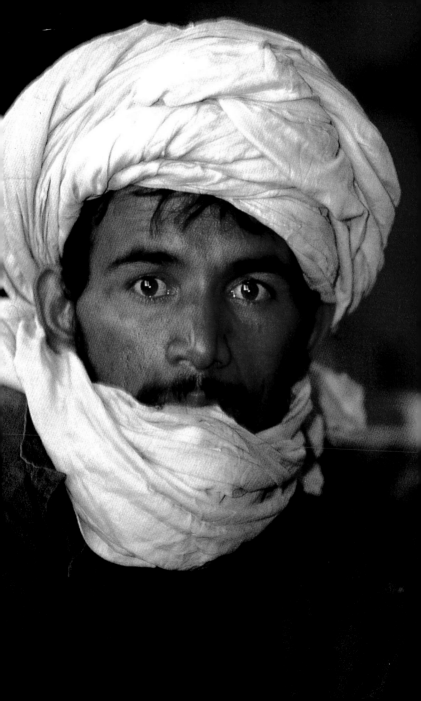

Hong Kong, 1985

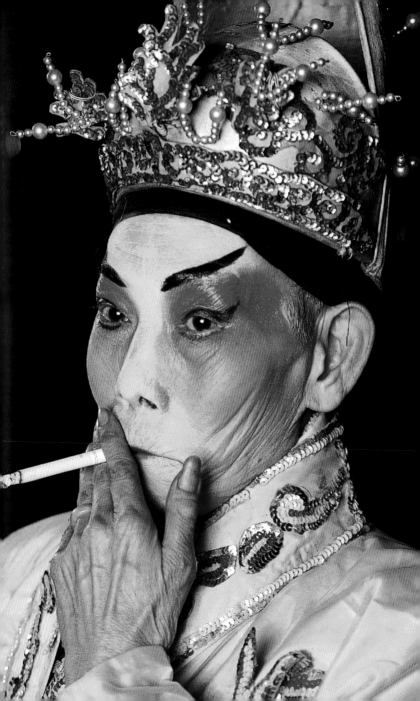

Tahoua, Niger, 1986

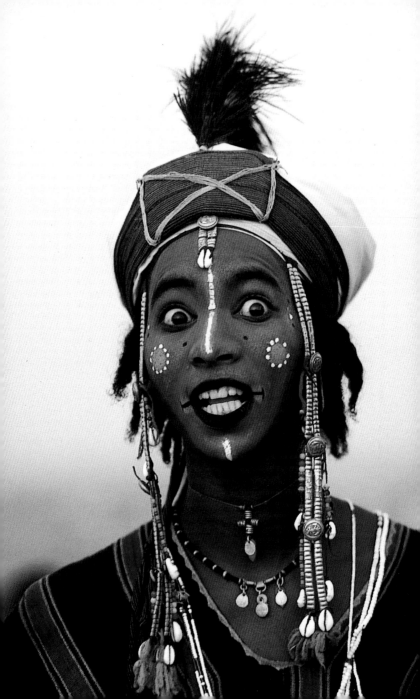

Rome, Italy, 1990

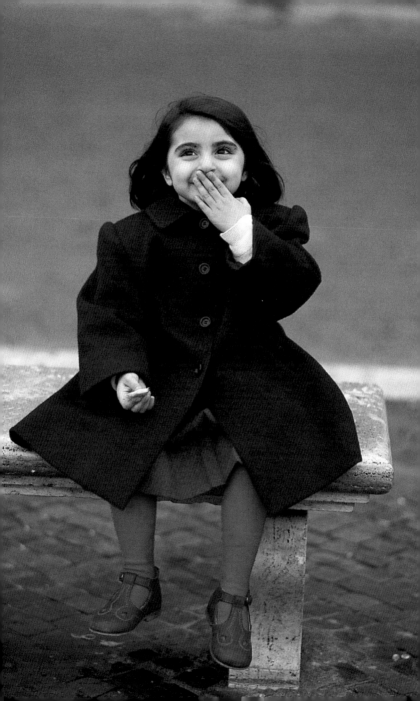

Chitral, Pakistan, 1980

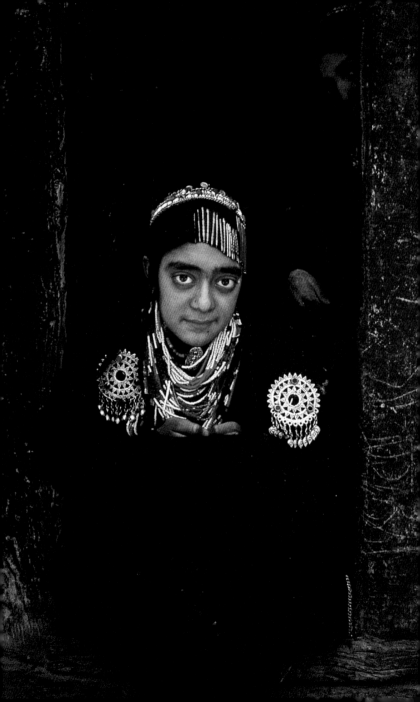

Timbuktu, Mali, 1985

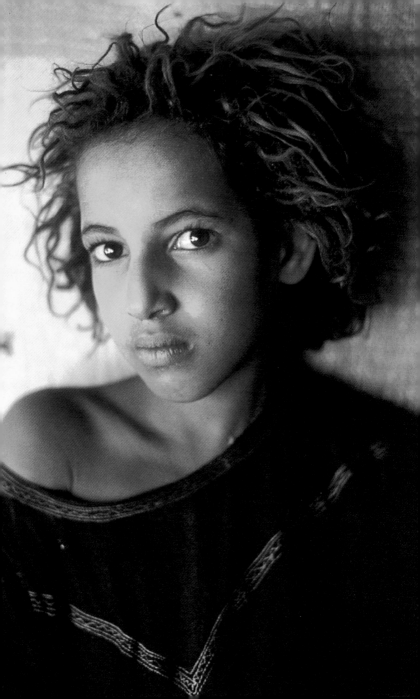

Basilan Island, Philippines, 1985

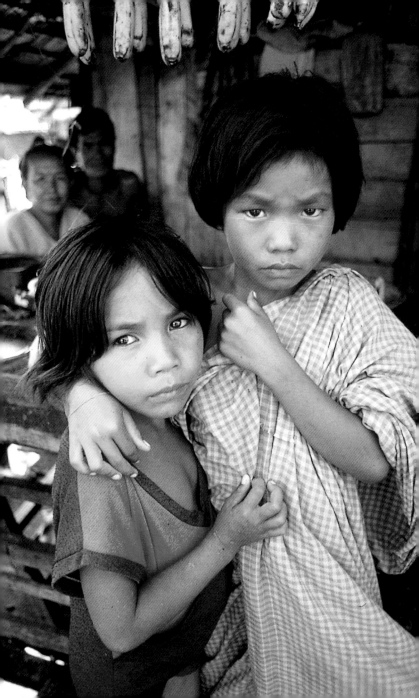

Porbandar, India, 1984

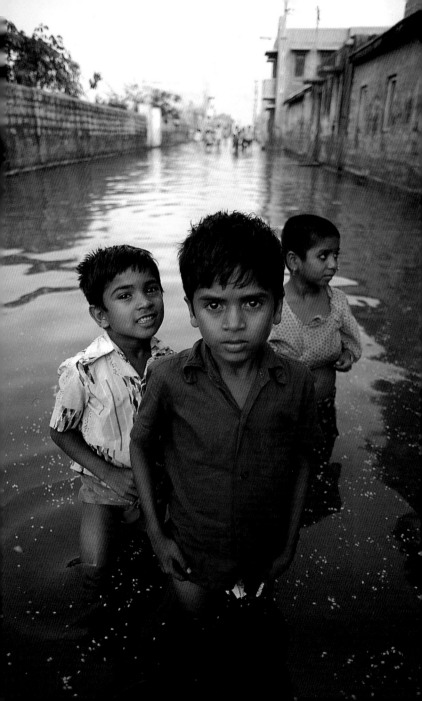

Bombay, India, 1994

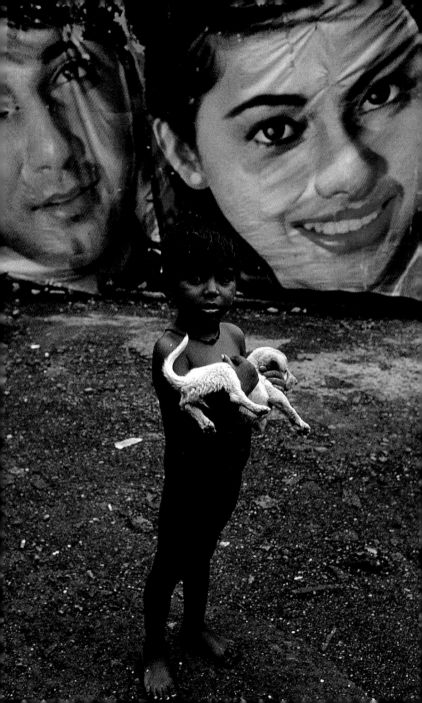

Luzon, Philippines, 1986

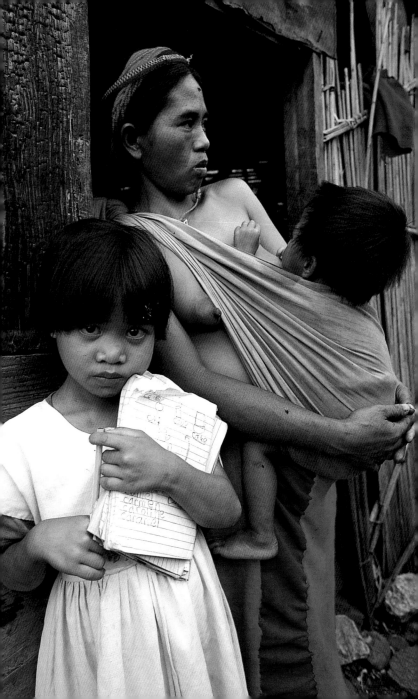

Dhaka, Bangladesh, 1983

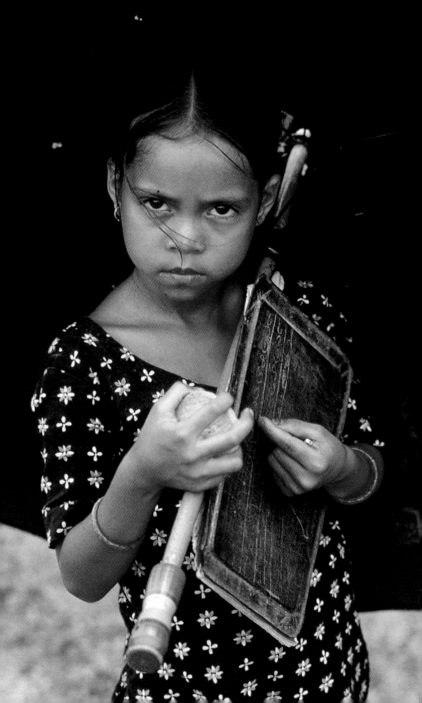

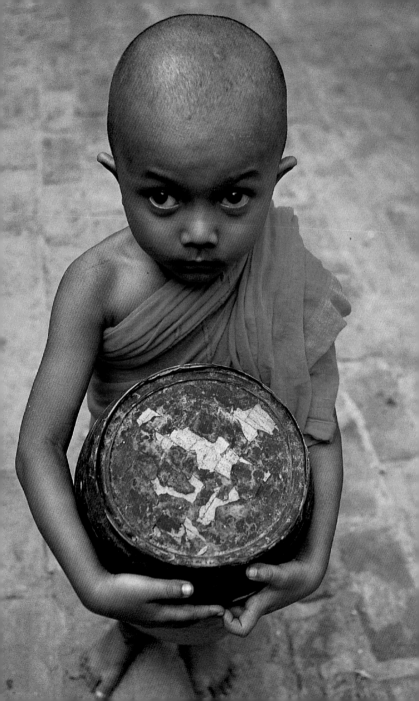

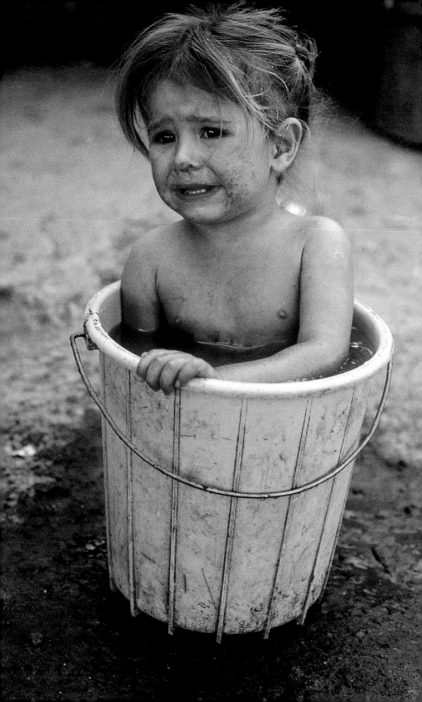

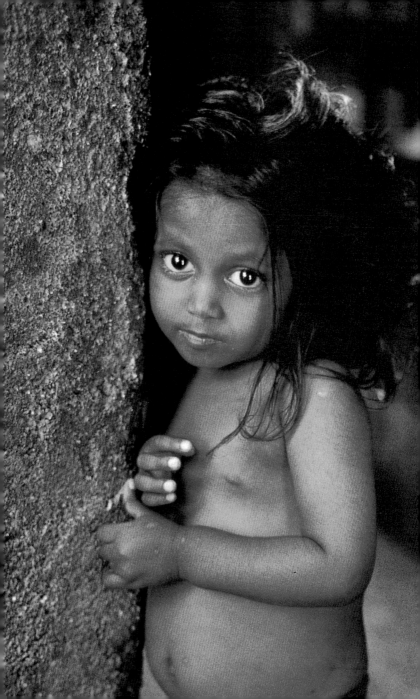

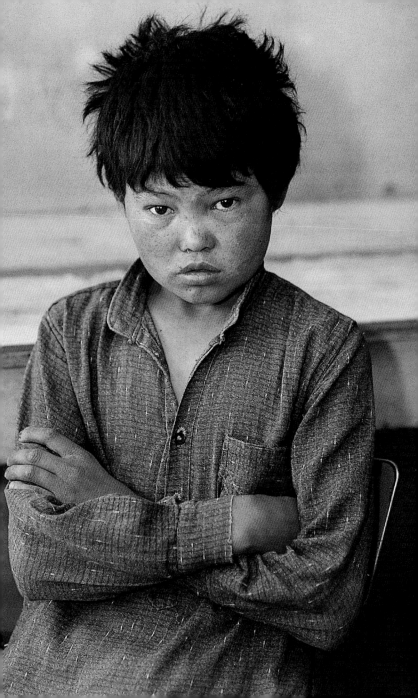

Darjeeling, India, 1994

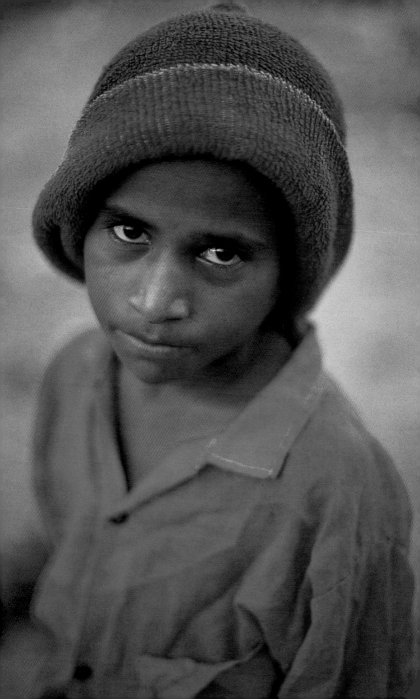

Bamako, Mali, 1985

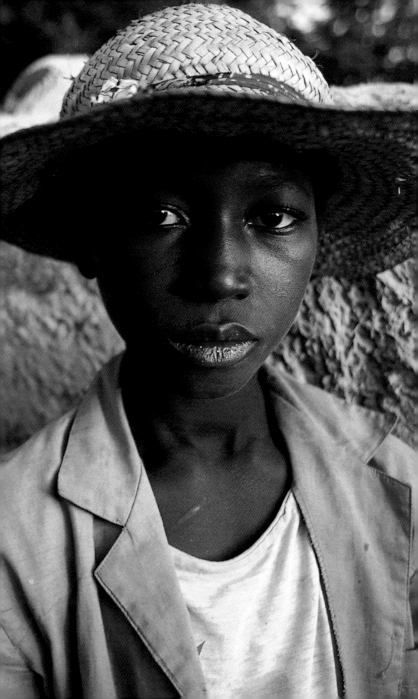

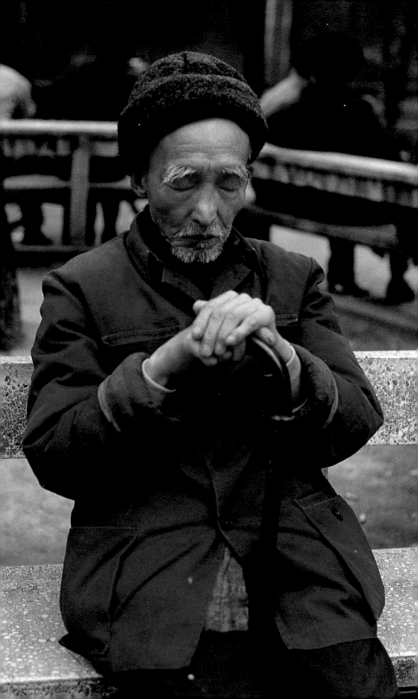

Beijing, China, 1989

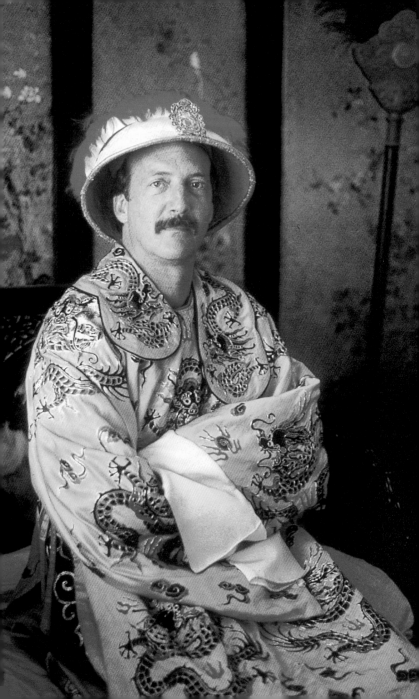

Bali, Indonesia, 1983

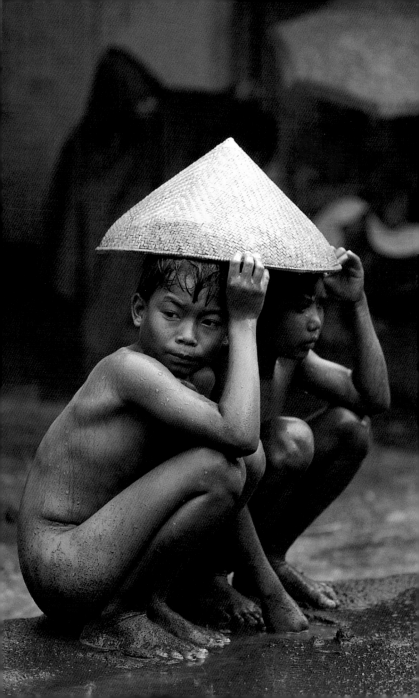

Sylhet, Bangladesh, 1983

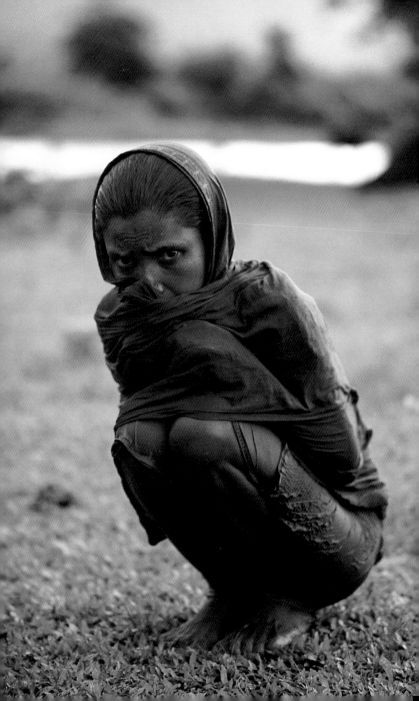

Rig-Rig, Chad, 1985

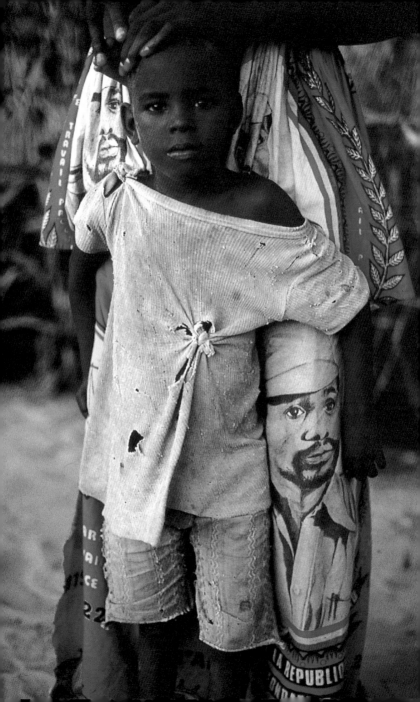

Herat, Afghanistan, 1991

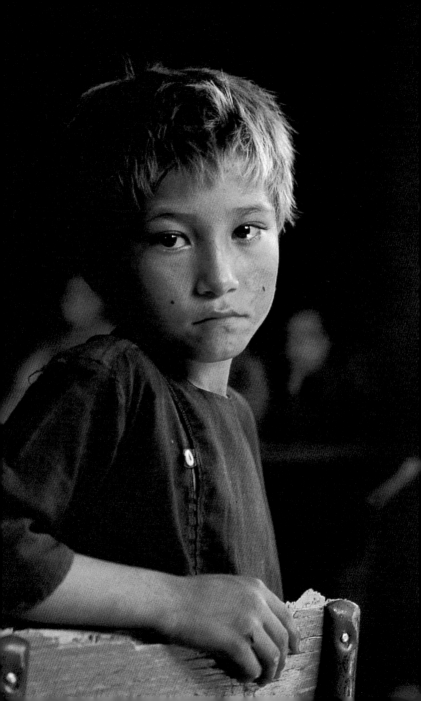

Rangoon, Burma, 1995

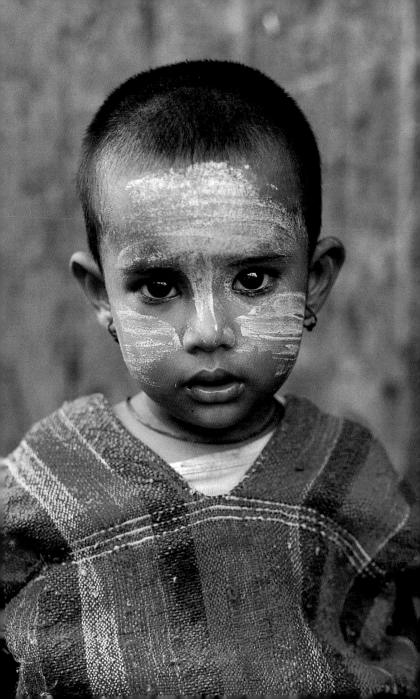

Kabul, Afghanistan, 1993

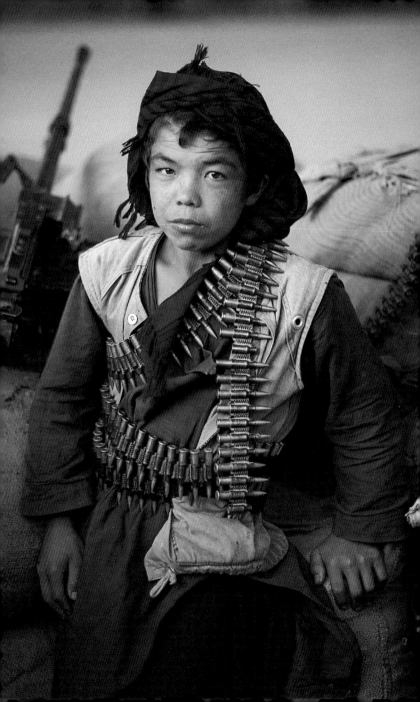

Marpha, Nepal, 1998

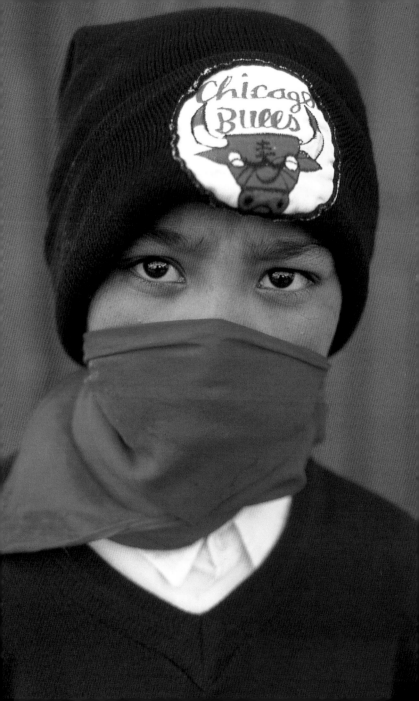

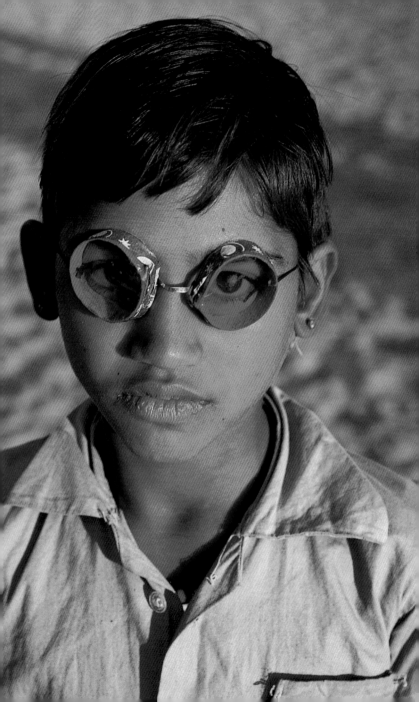

Kuala Lumpur, Malaysia, 1990

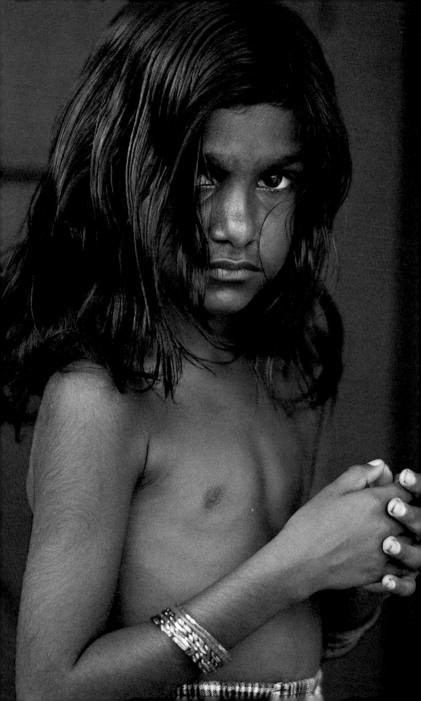

Aranyaprathet, Thailand, 1979

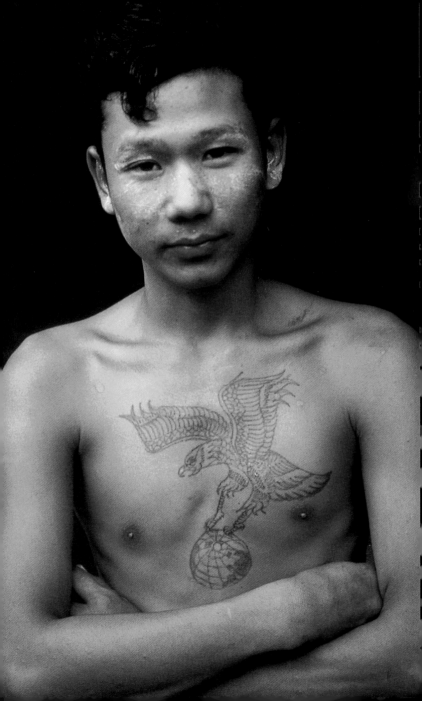

Haridwar, India, 1998

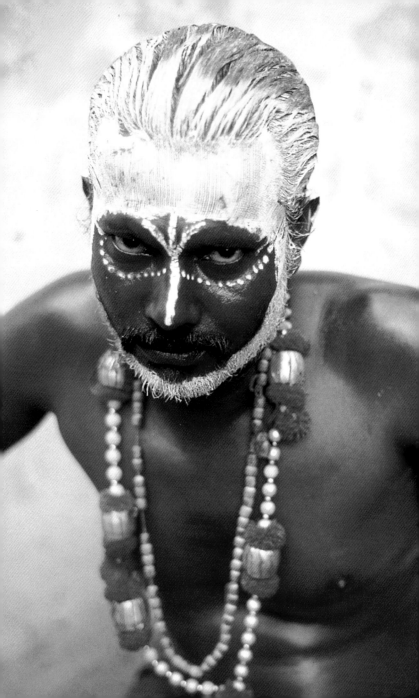

Baghdad, Iraq, 1986

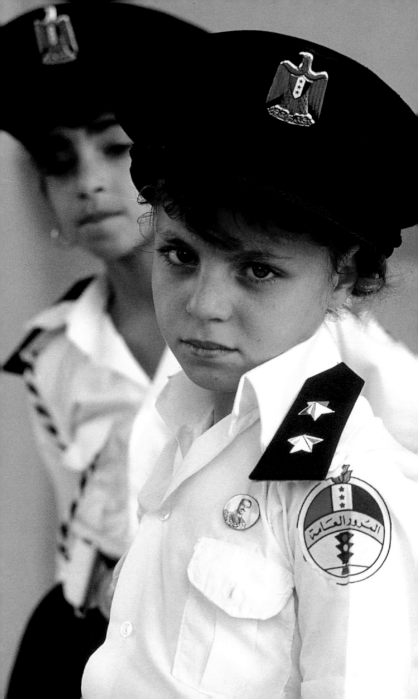

Hong Kong, 1984

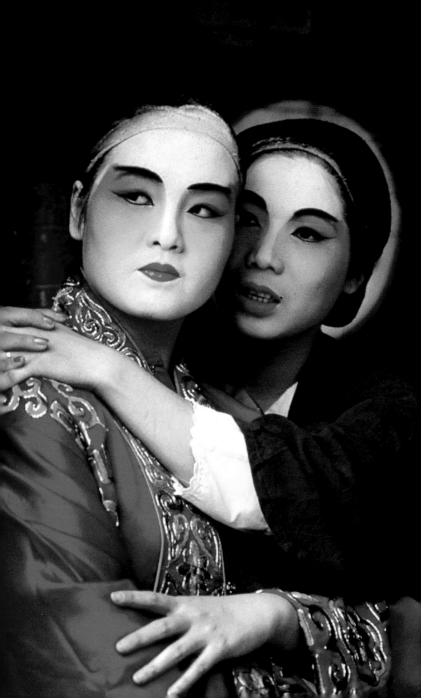

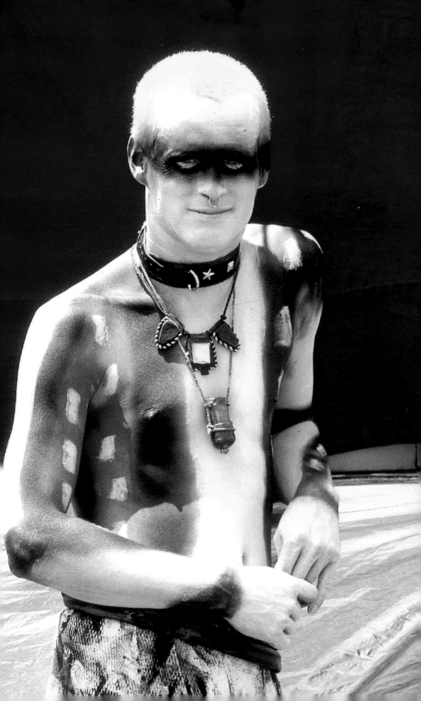

Iloilo, Philippines, 1985

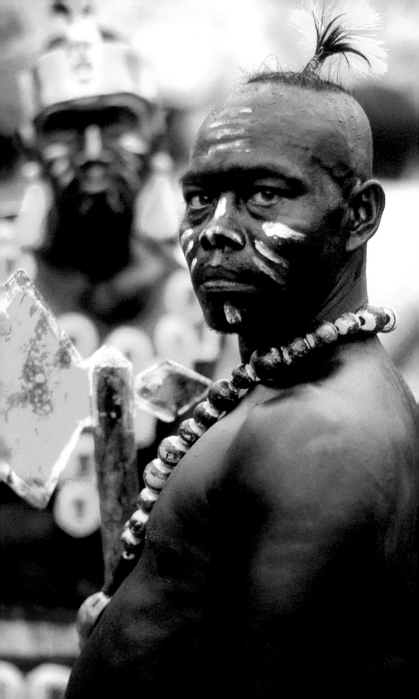

Darwin, Australia, 1984

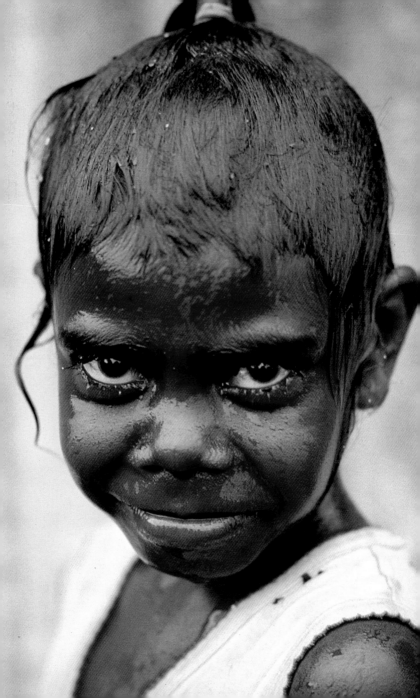

Chicago, USA, 1987

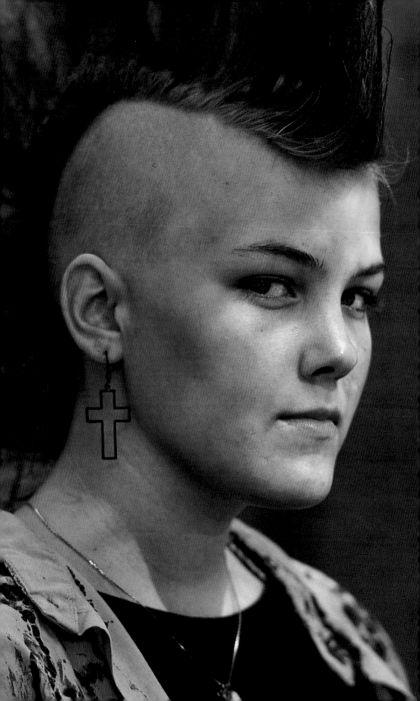

Mandalay, Burma, 1995

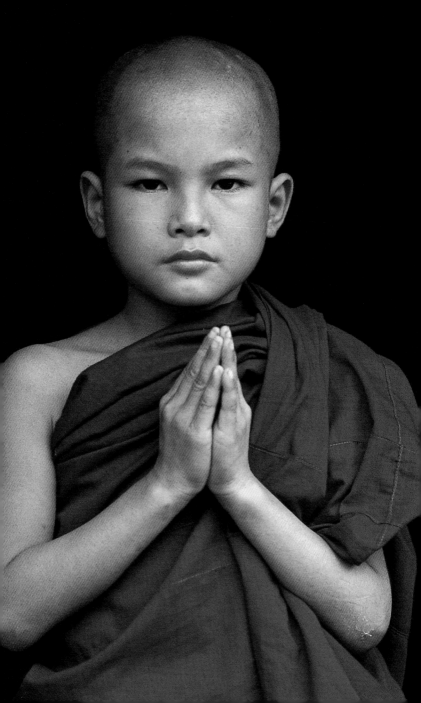

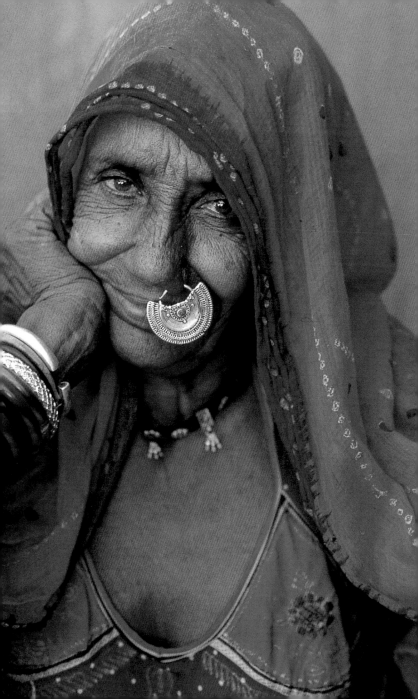

Ladakh, India, 1996

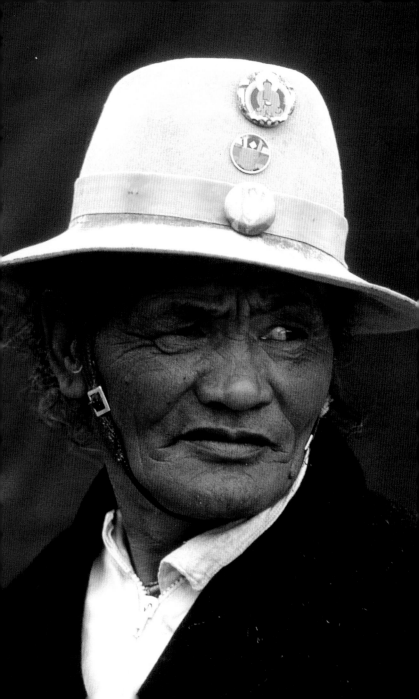

Banaue, Philippines, 1985

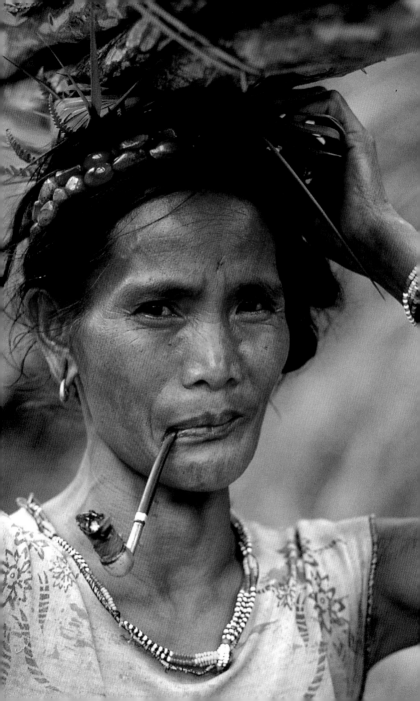

Ladakh, India, 1997

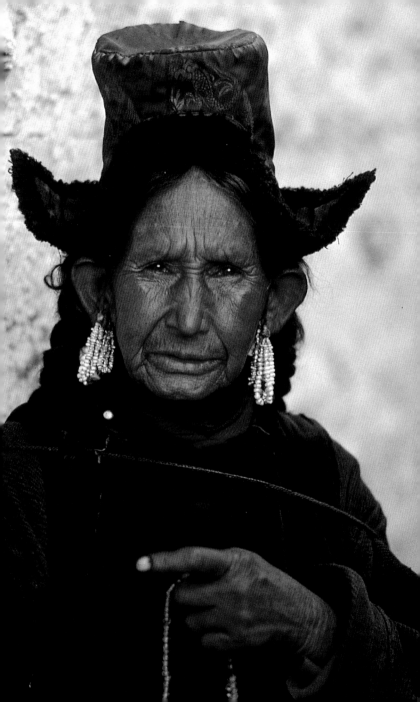

Bamian, Afghanistan, 1992

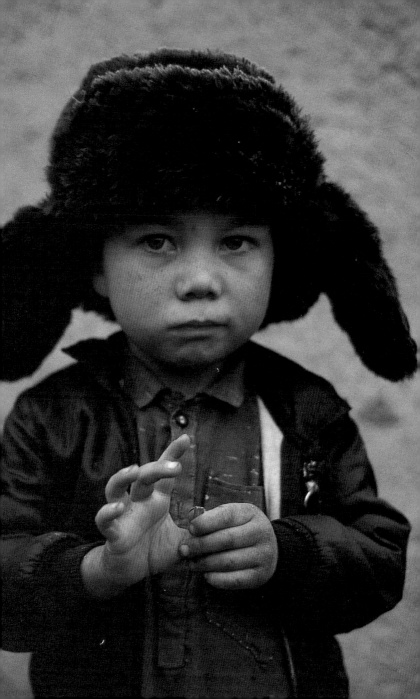

Chicago, USA, 1987

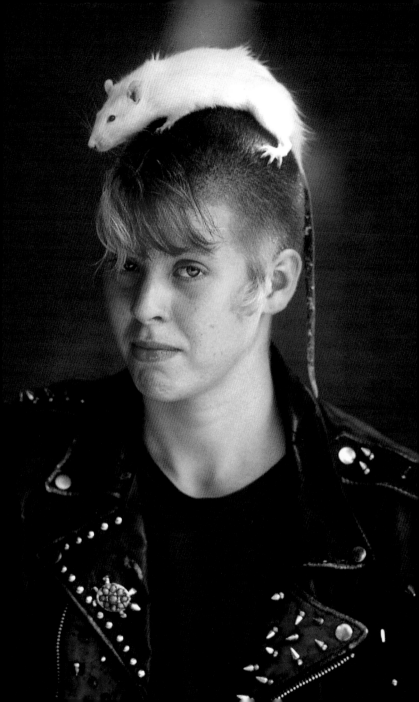

Bombay, India, 1994

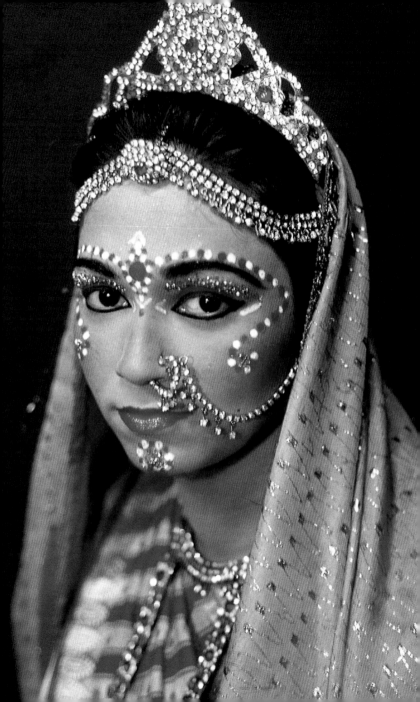

Loikaw, Burma, 1995

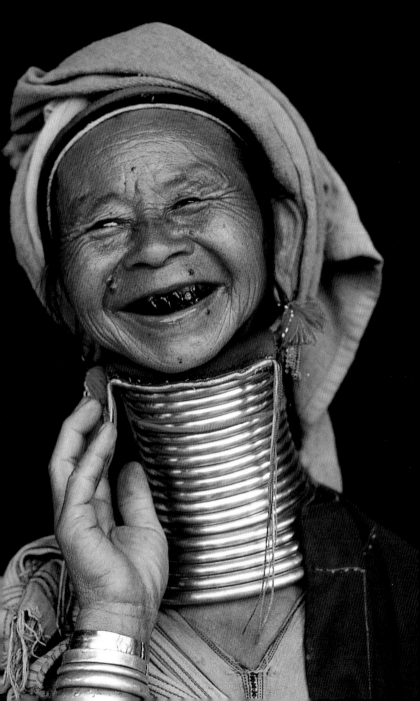

Dharmsala, India, 1997

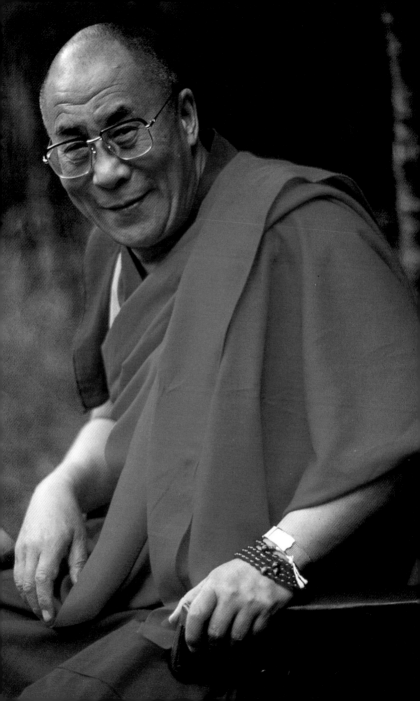

Porbandar, India, 1983

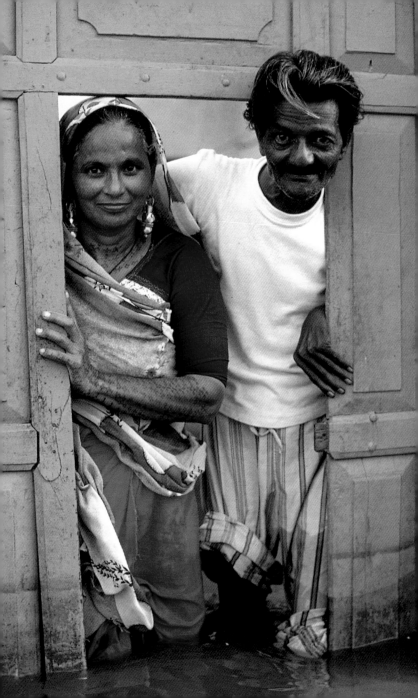

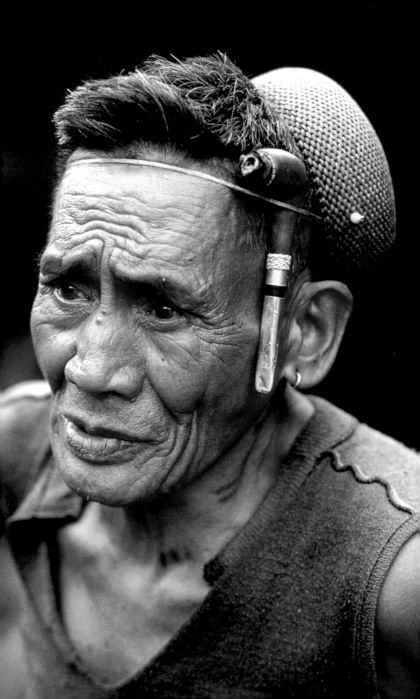

Gao, Mali, 1986

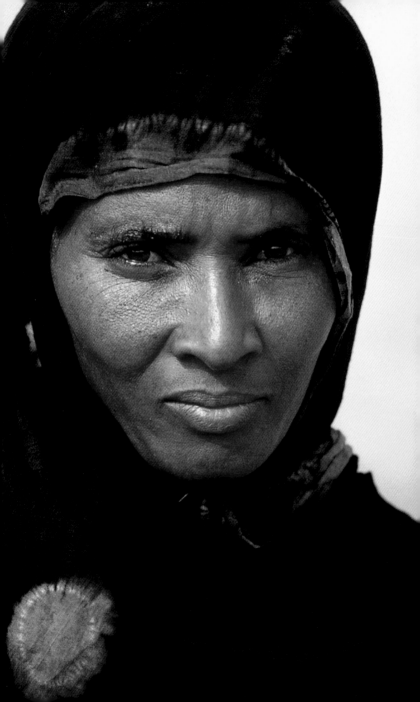

Herat, Afghanistan, 1991

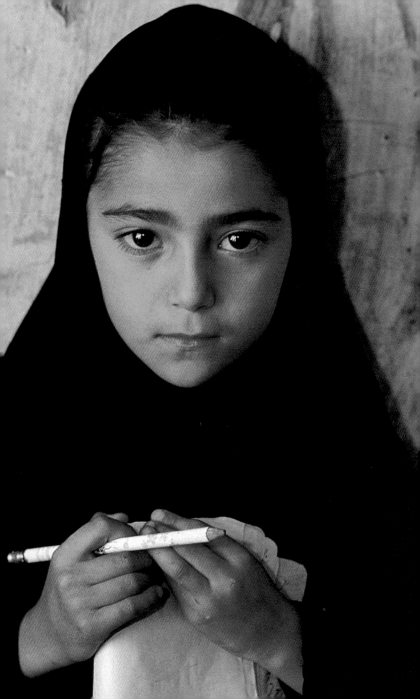

Asmar, Afghanistan, 1979

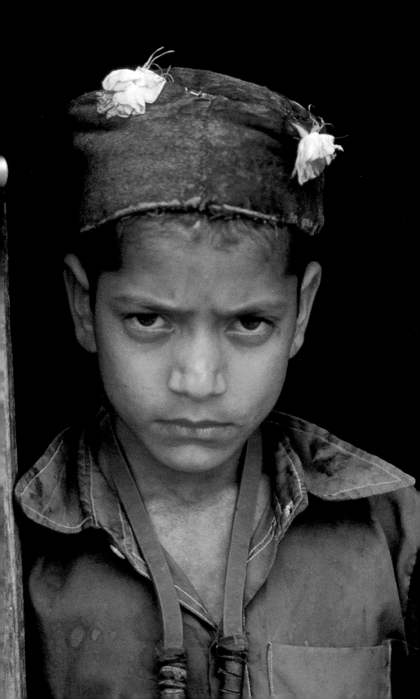

Kandahar, Afghanistan, 1990

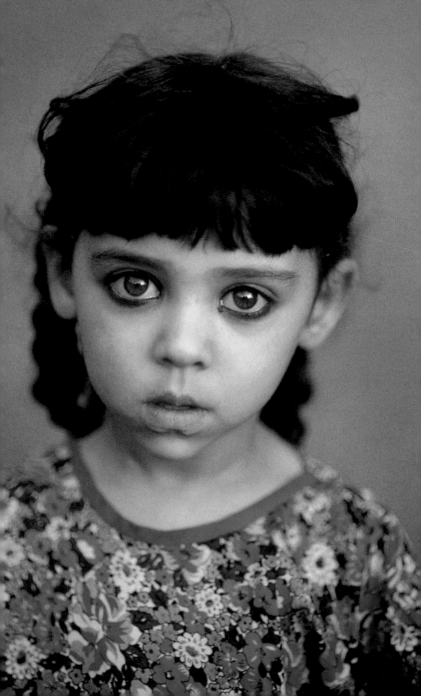

Herat, Afghanistan, 1992

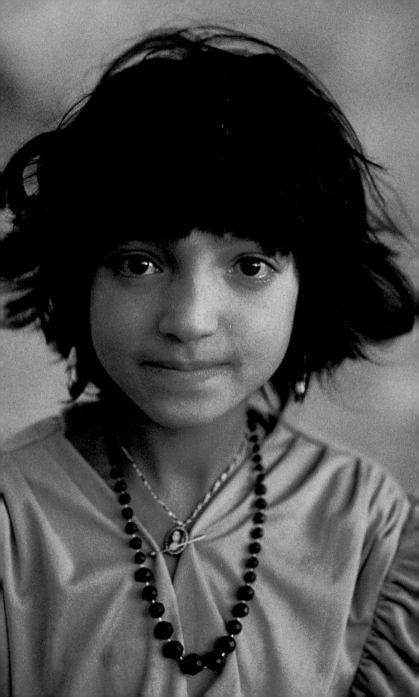

Bombay, India, 1995

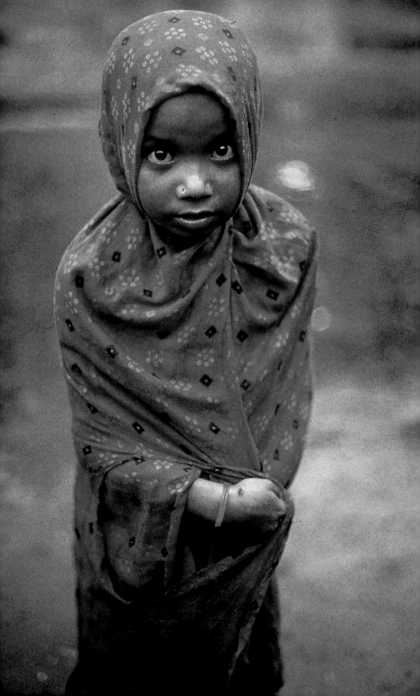

Niamey, Niger, 1987

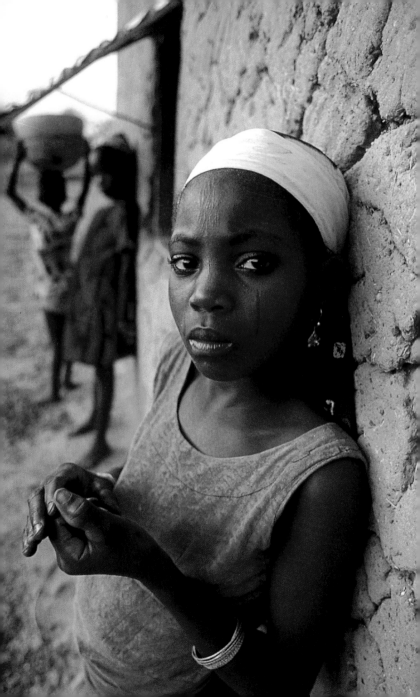

Marseilles, France, 1989

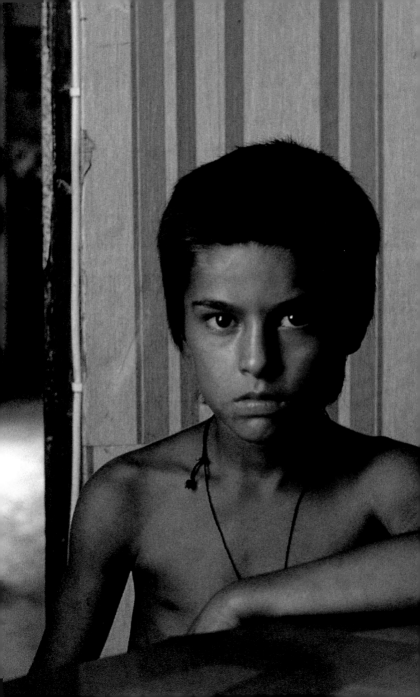

Rangoon, Burma, 1995

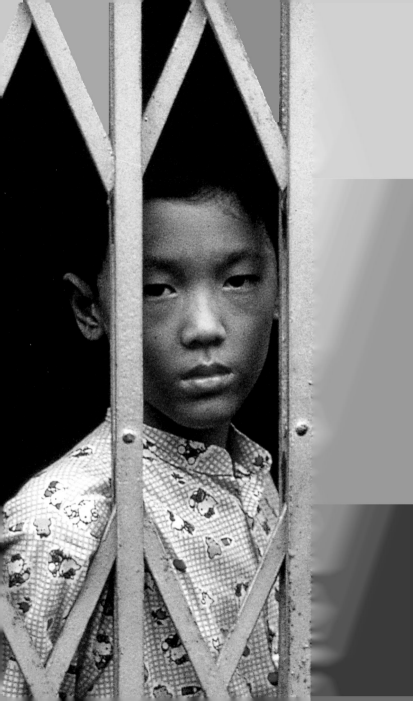

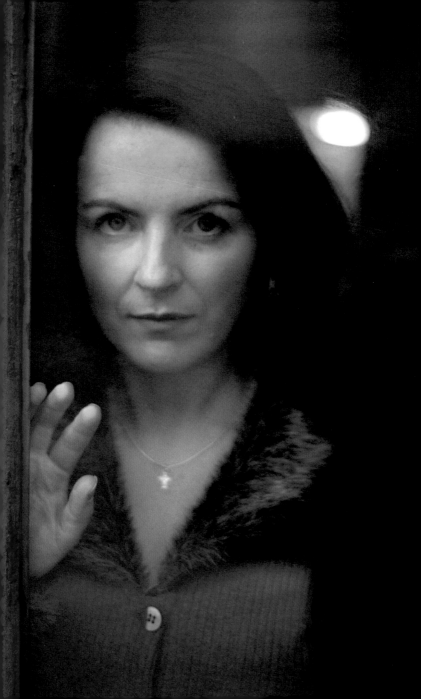

Banaue, Philippines, 1985

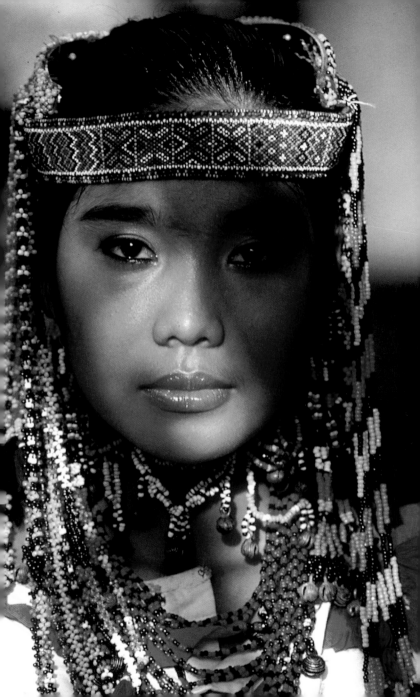

Baluchistan, Pakistan, 1981

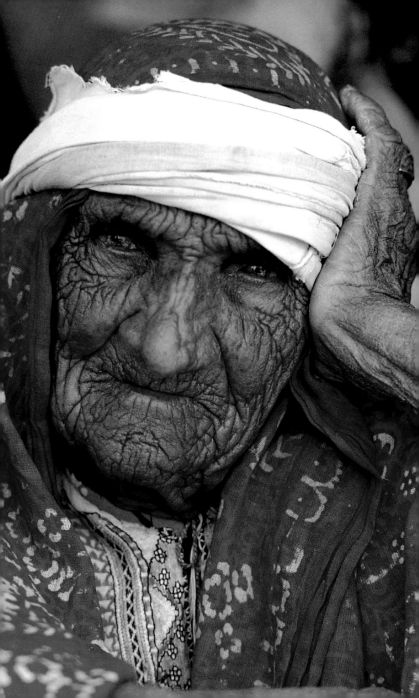

Kabul, Afghanistan, 1988

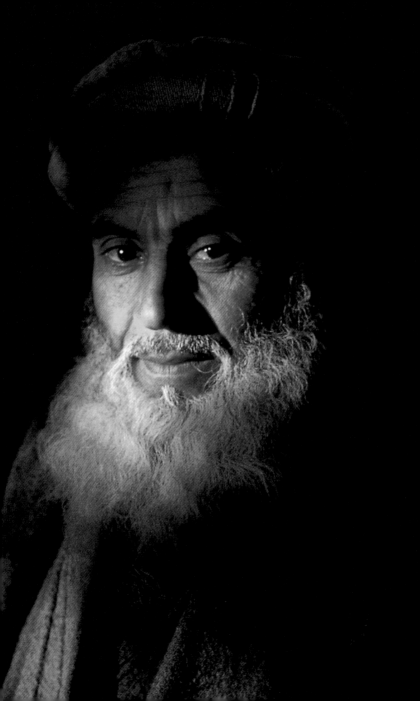

Insein, Burma, 1984

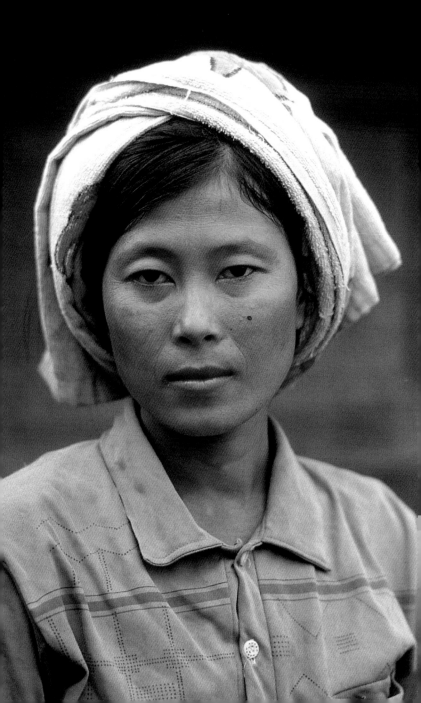

Aranyaprathet, Thailand, 1980

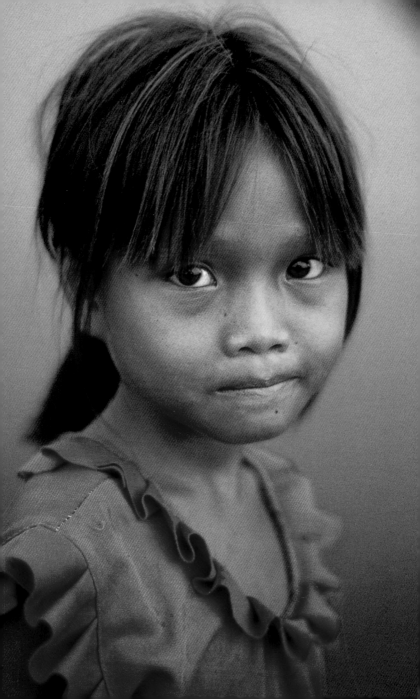

Marseilles, France, 1989

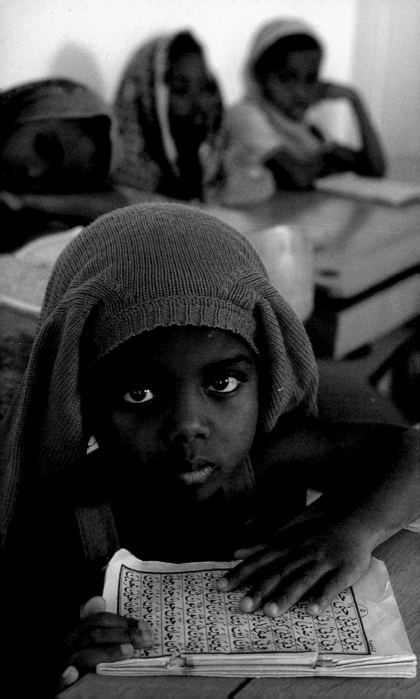

Haridwar, India, 1998

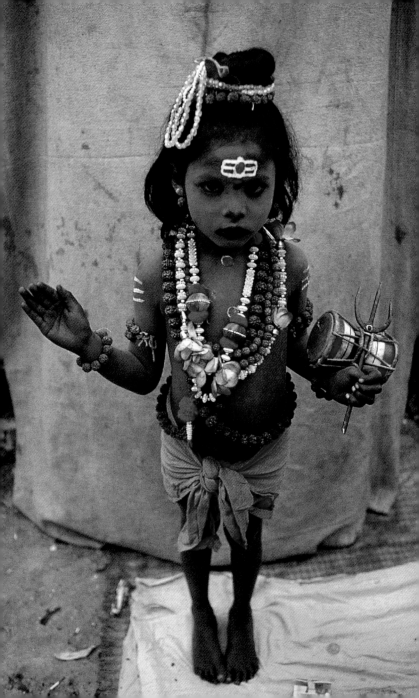

Iloilo, Philippines, 1985

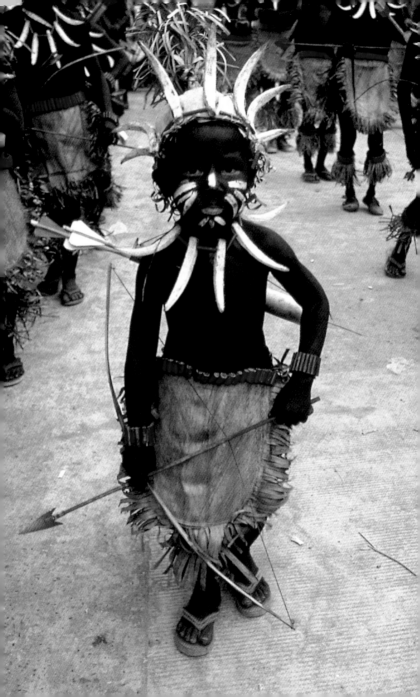

Ladakh, India, 1996

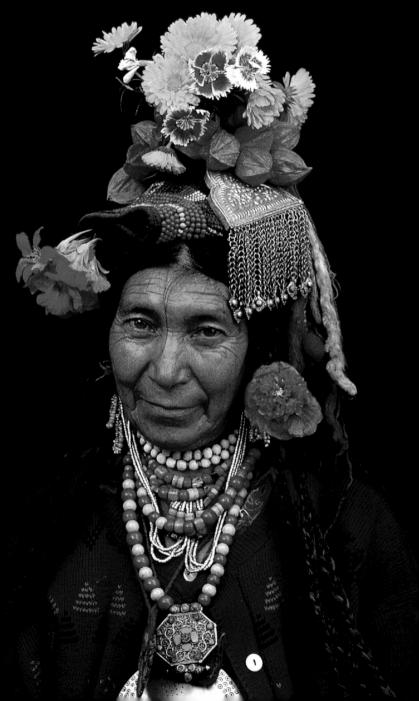

Khartoum, Sudan, 1985

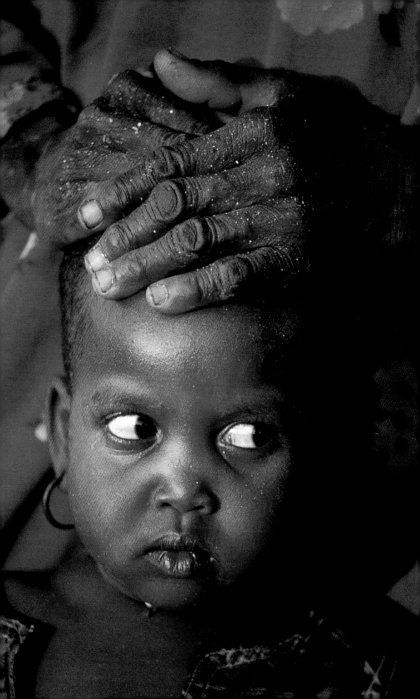

Kandahar, Afghanistan, 1990

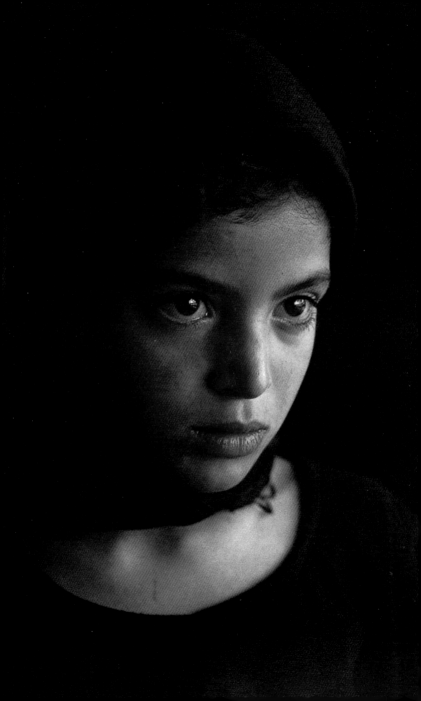

Kosovo, Yugoslavia, 1989

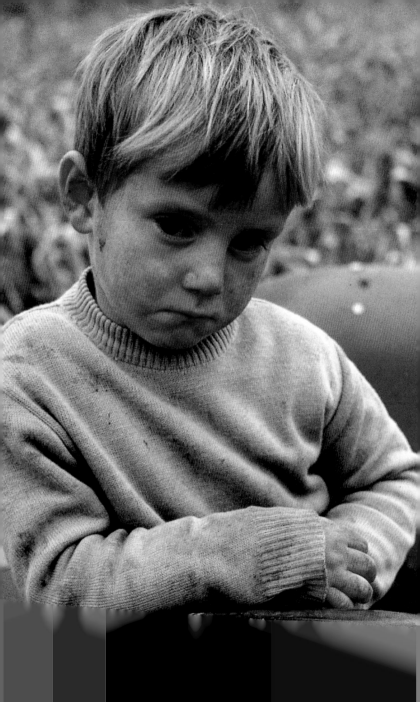

Jaipur, India, 1982

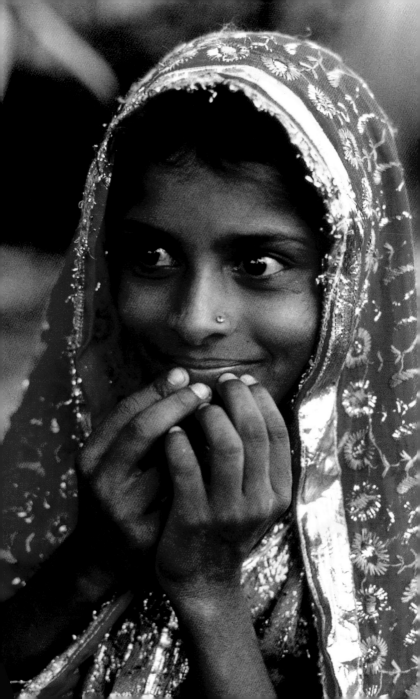

Jabal os Siraj, Afghanistan, 1992

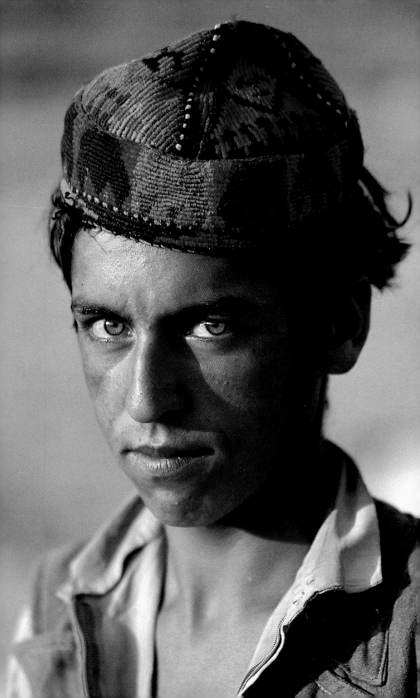

Kabul, Afghanistan, 1993

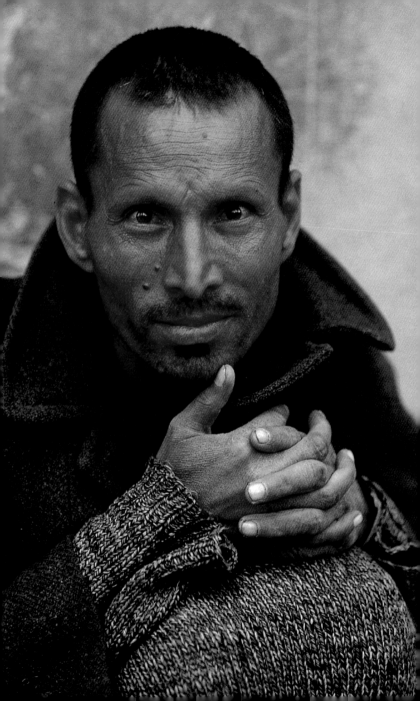

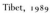
Tibet, 1989

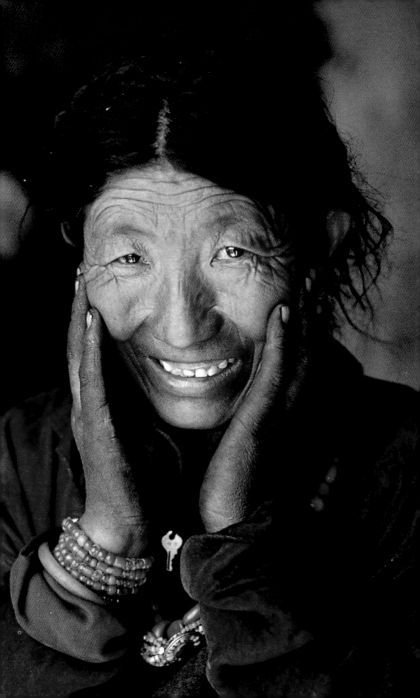

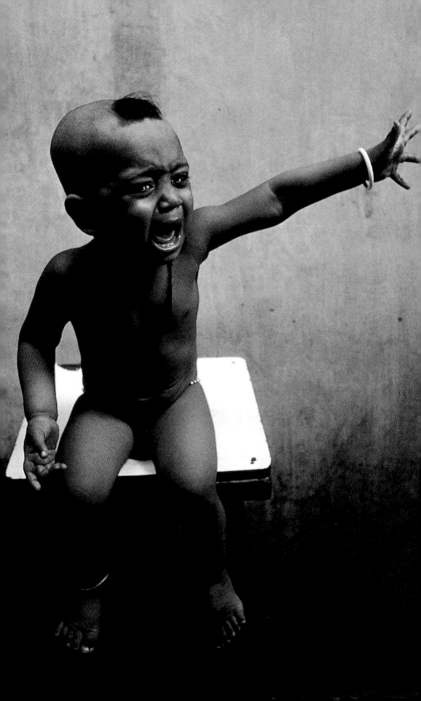

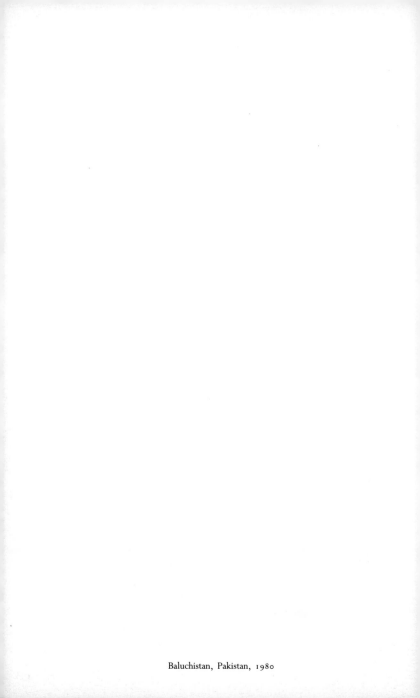

Baluchistan, Pakistan, 1980

Manila, Philippines, 1985

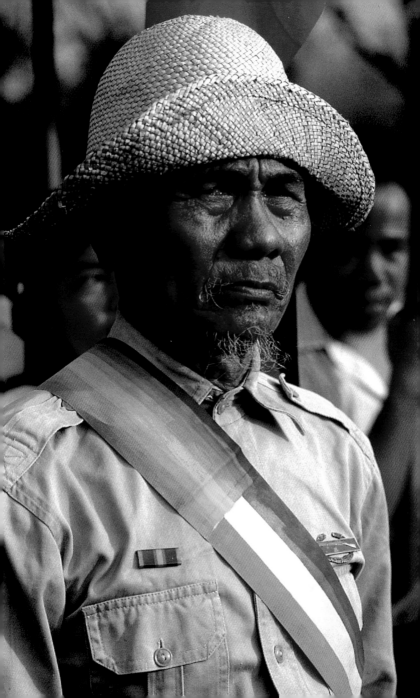

Los Angeles, USA, 1991

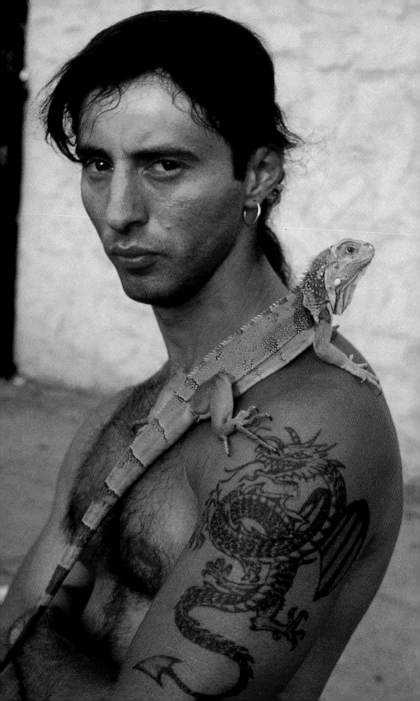

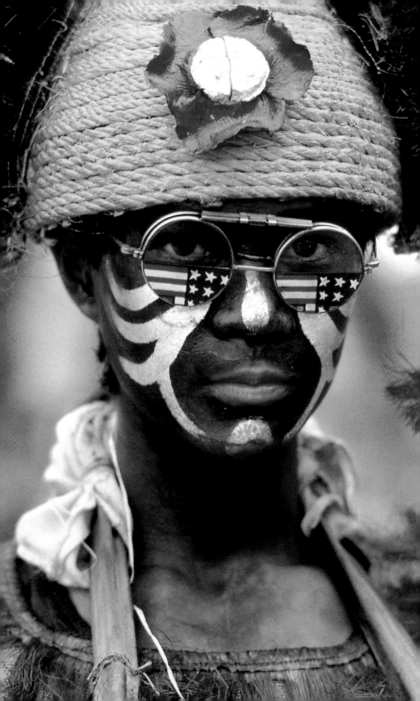

Los Angeles, USA, 1991

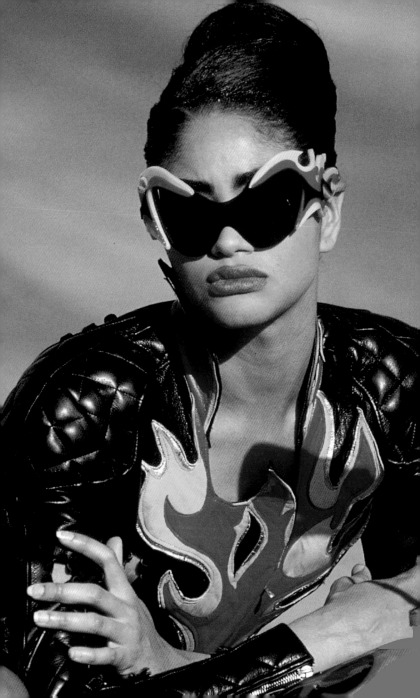

Los Angeles, USA, 1991

Ladakh, India, 1997

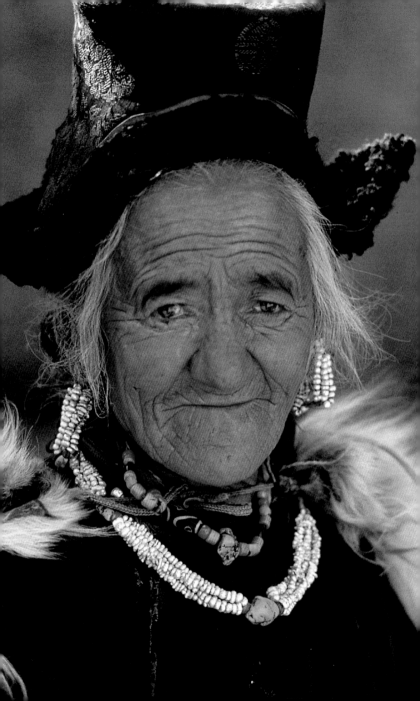

Lhasa, Tibet, 1989

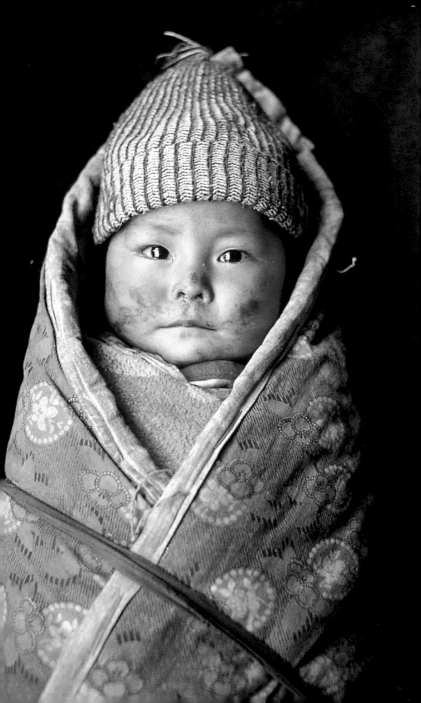

Niamey, Niger, 1985

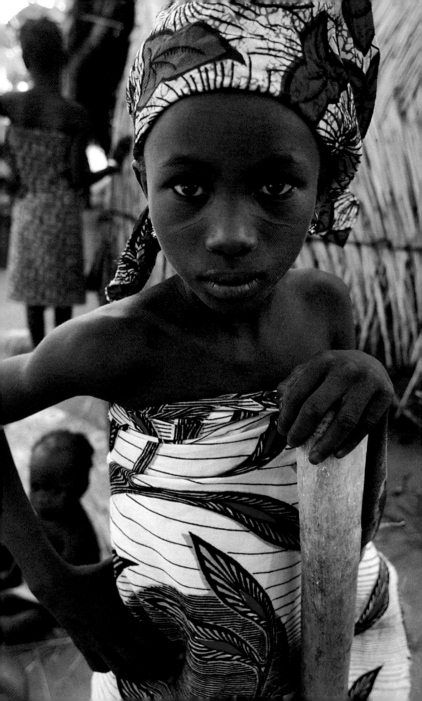

Filadelfia, Paraguay, 1985

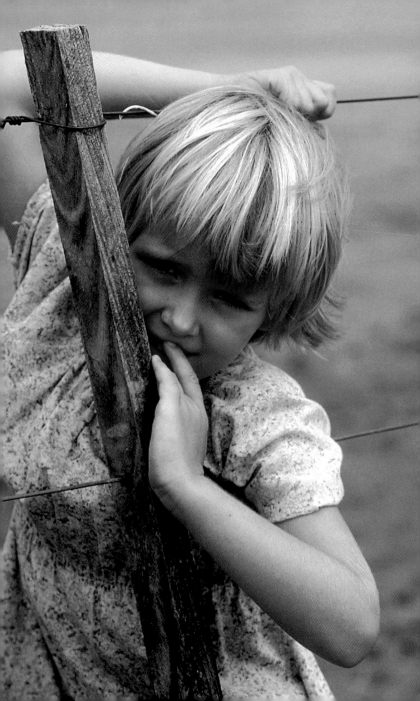

Zamboanga, Philippines, 1985

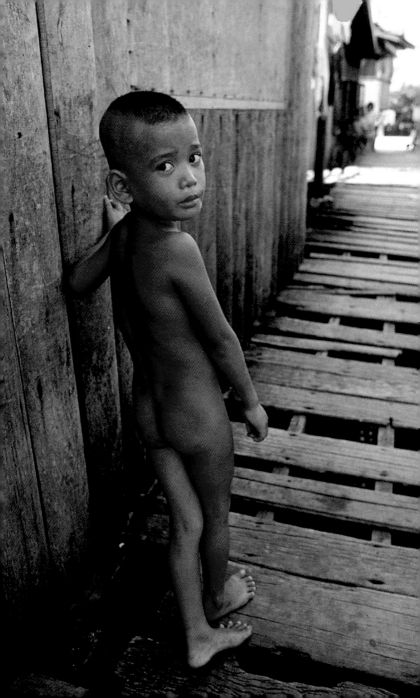

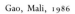
Gao, Mali, 1986

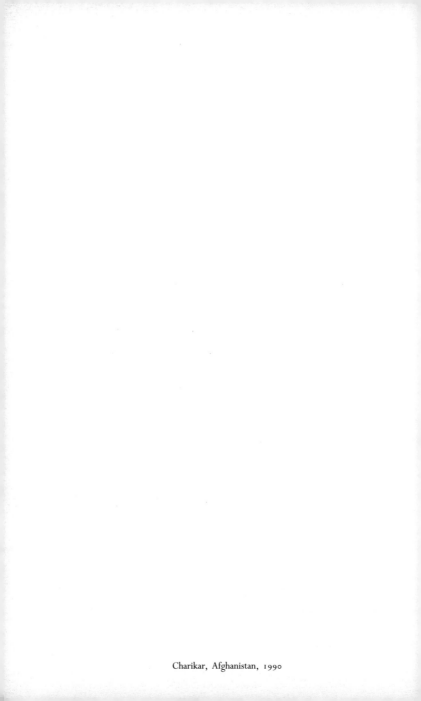

Charikar, Afghanistan, 1990

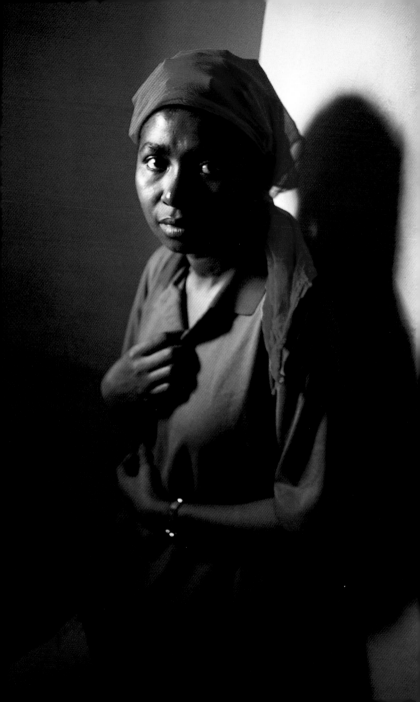

Los Angeles, USA, 1990

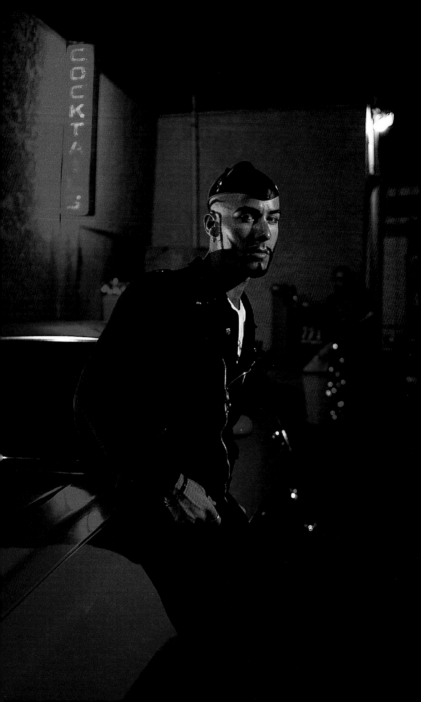

Kuala Lumpur, Malaysia, 1989

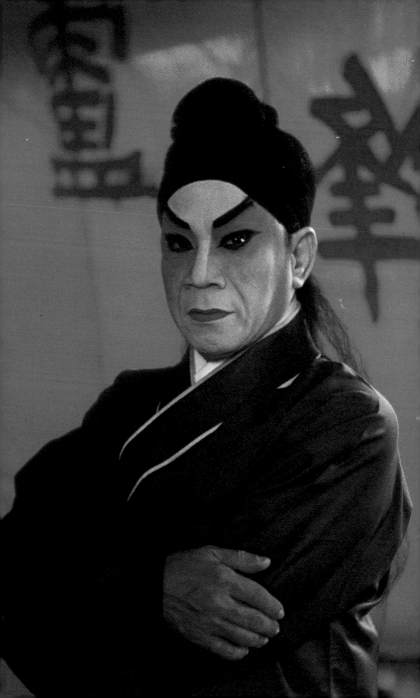

Ladakh, India, 1978

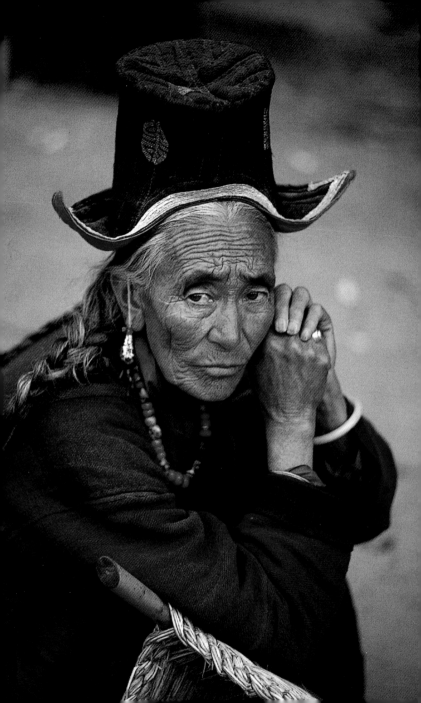

New York City, USA, 1994

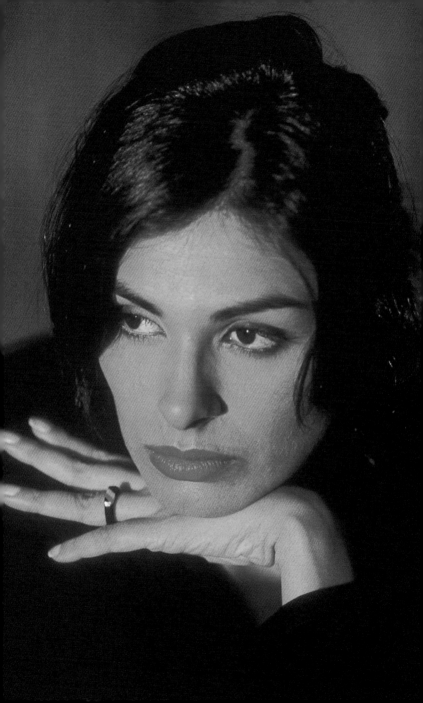

Kabul, Afghanistan, 1991

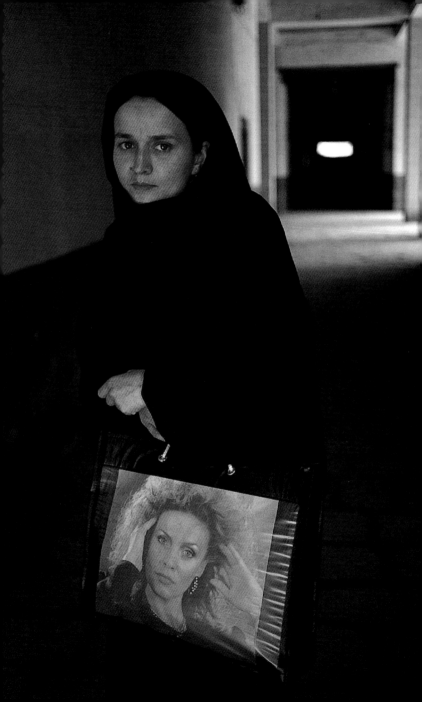

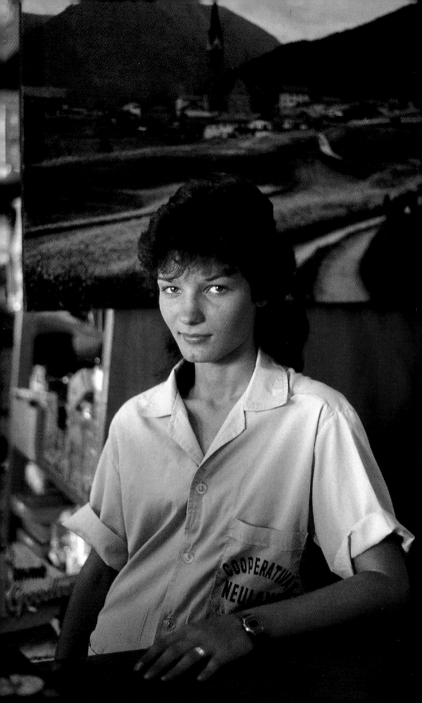

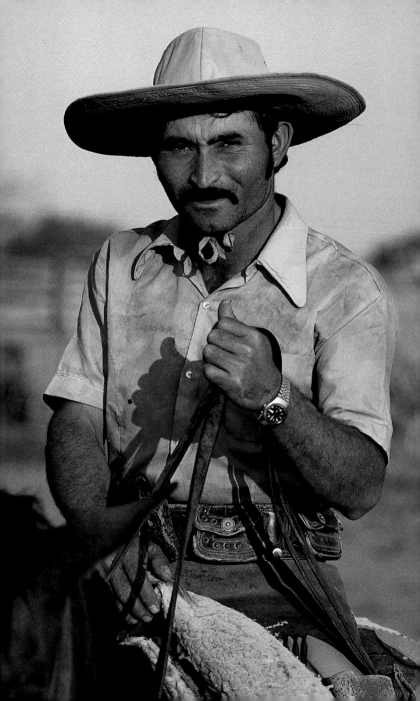

Haridwar, India, 1998

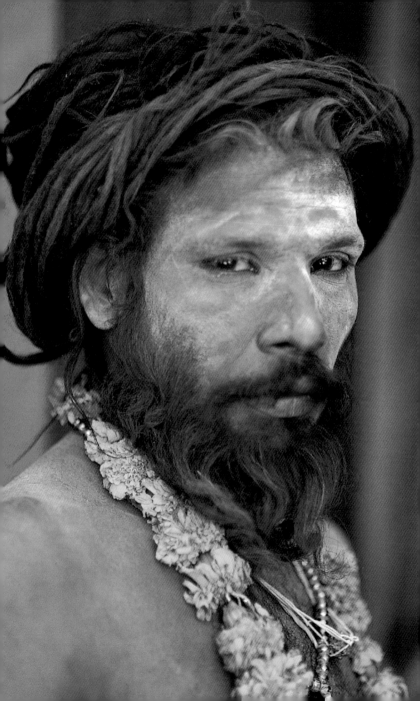

Rangoon, Burma, 1995

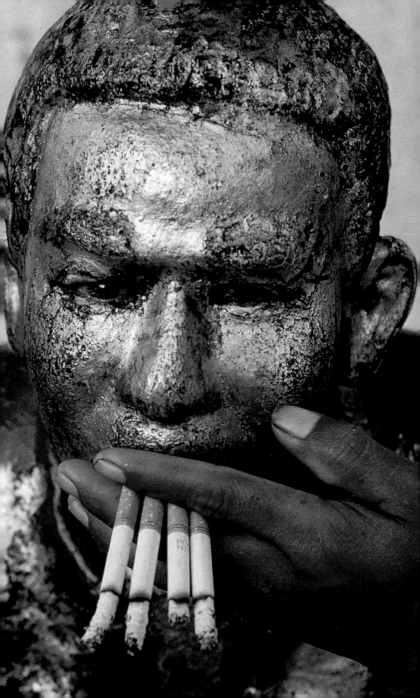

Amritsar, India, 1996

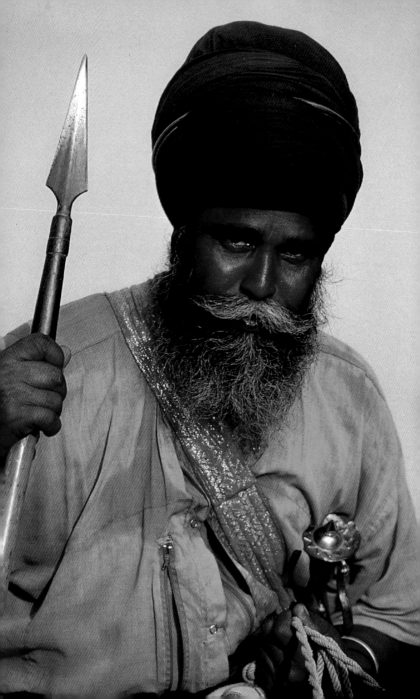

Amritsar, India, 1996

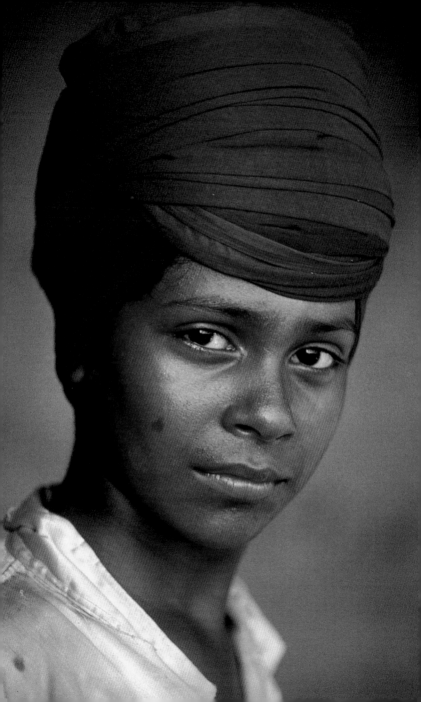

Los Angeles, USA, 1992

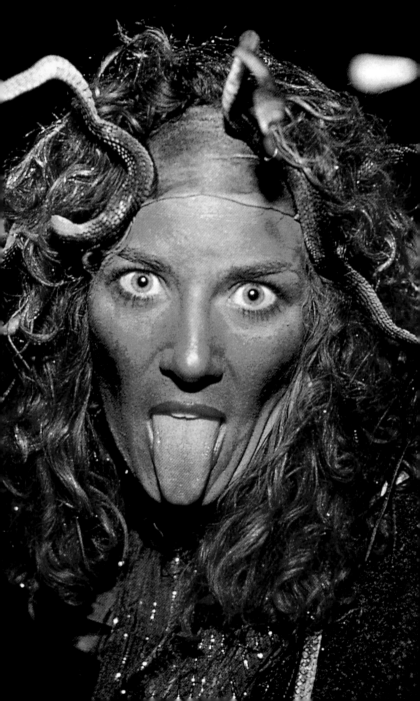

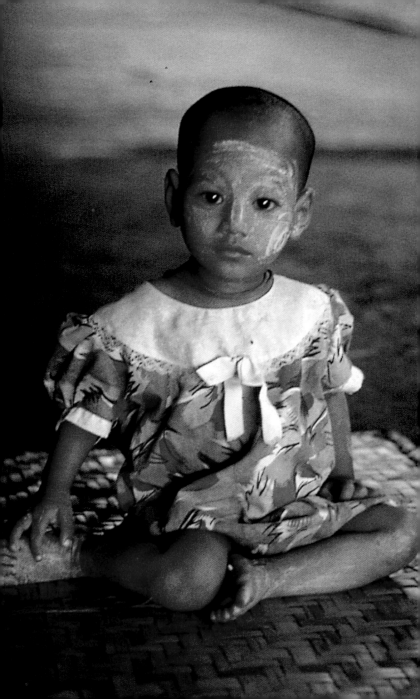

Kabul, Afghanistan, 1992

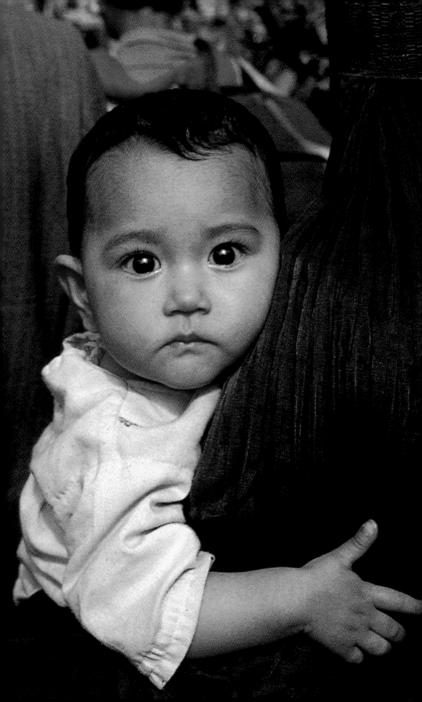

Mopti, Mali, 1986

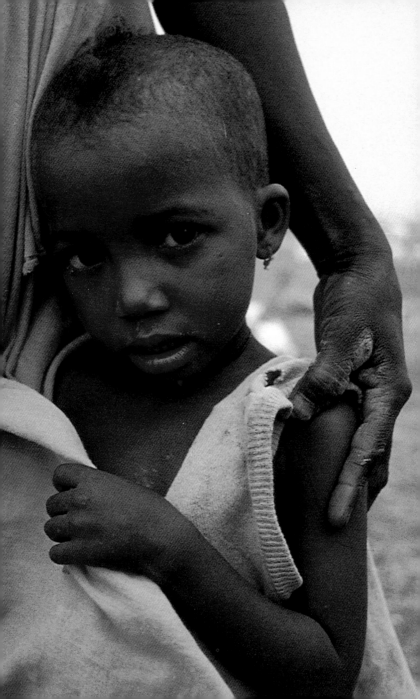

Lhasa, Tibet, 1989

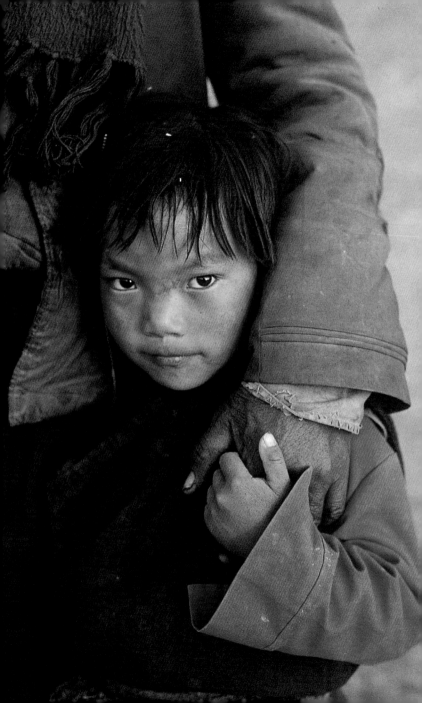

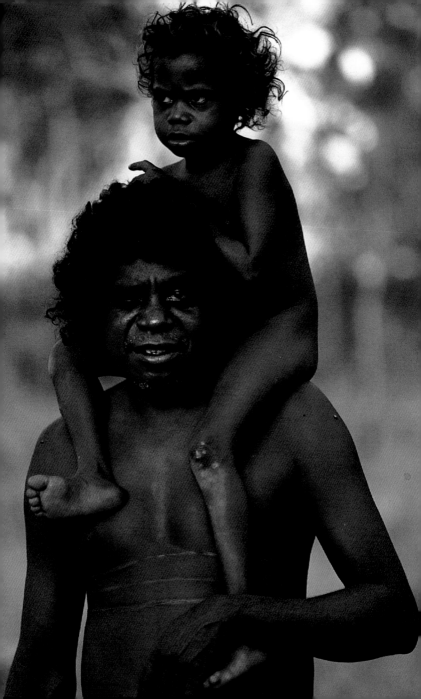

Jaipur, India, 1996

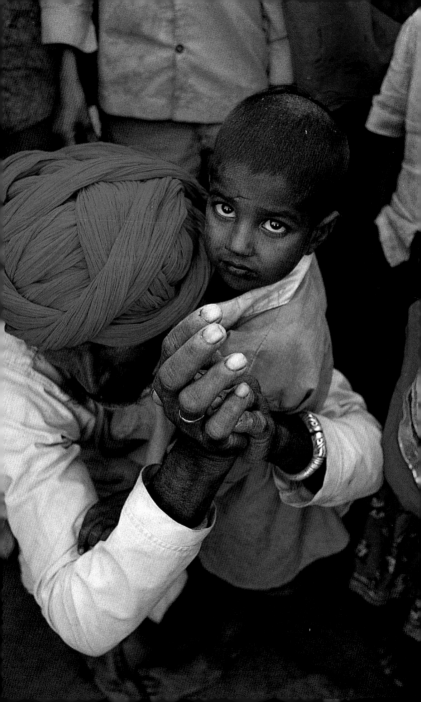

Rawalpindi, Pakistan, 1984

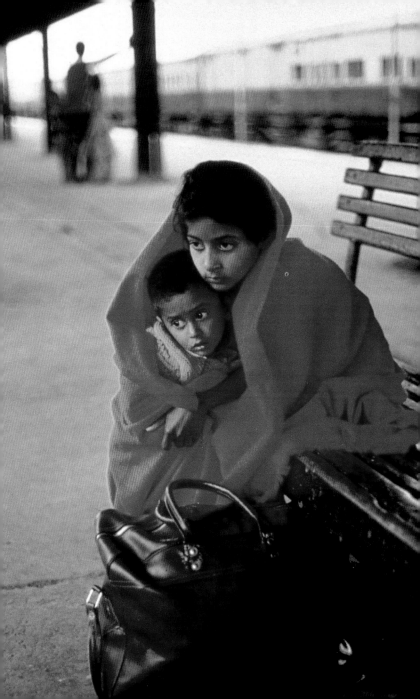

Feyzabad, Afghanistan, 1990

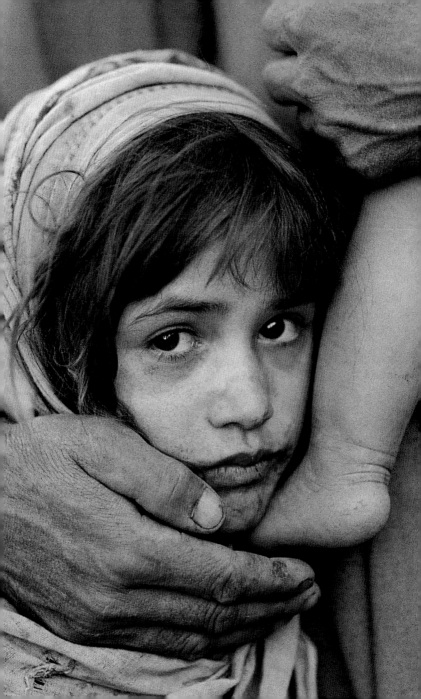

Bengal, India, 1982

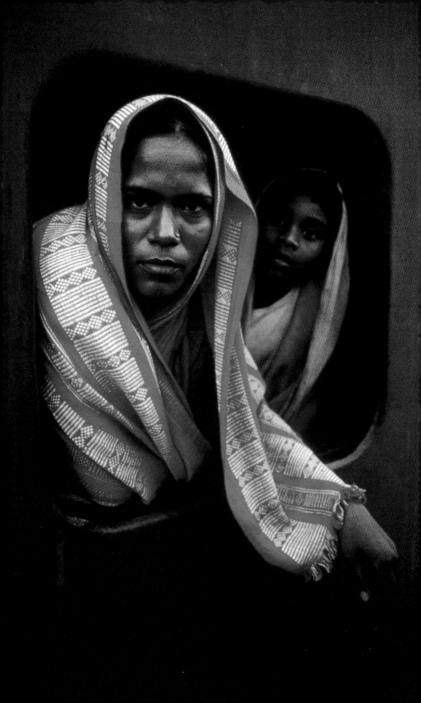

West Bengal, India, 1983

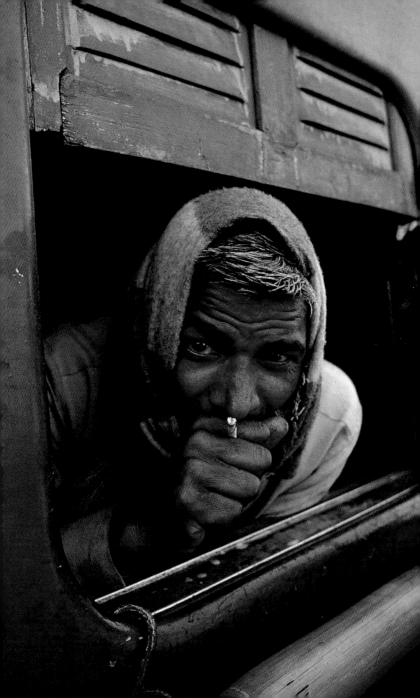

Hindu Kush Mountains, Afghanistan, 1980

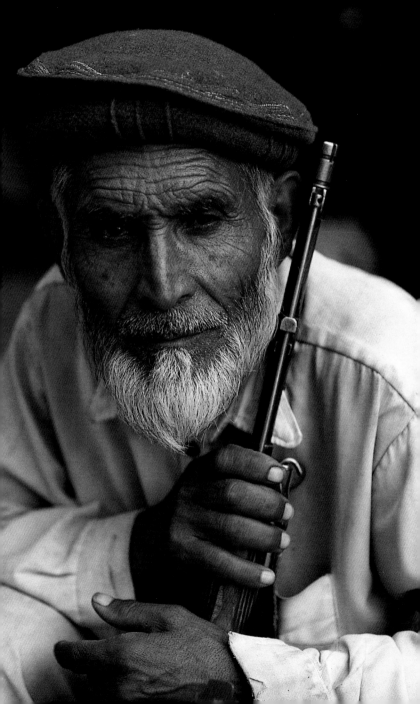

Manang, Nepal, 1998

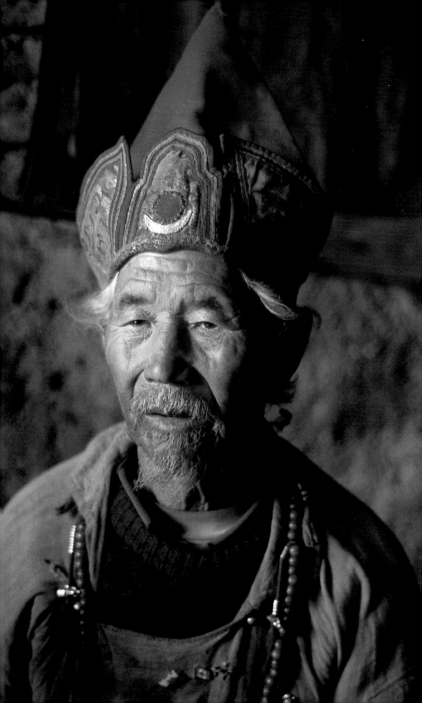

Kamdesh, Afghanistan, 1980

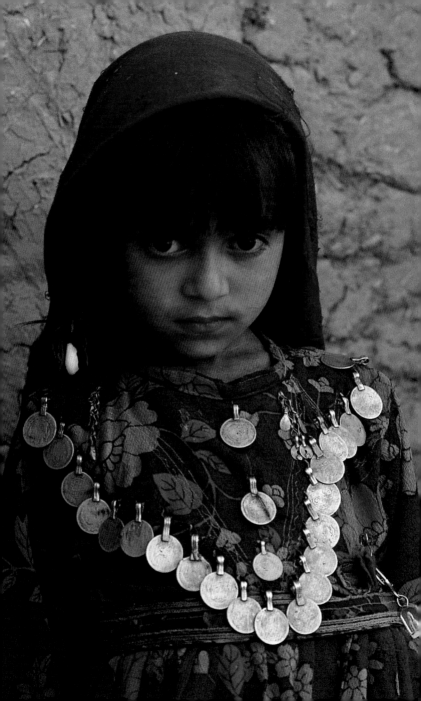

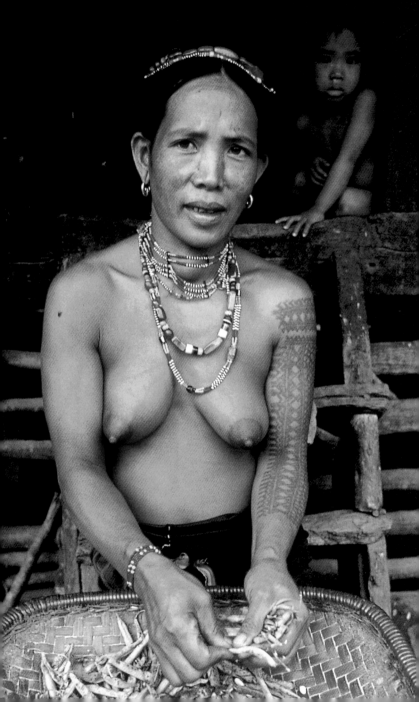

Ghazni, Afghanistan, 1991

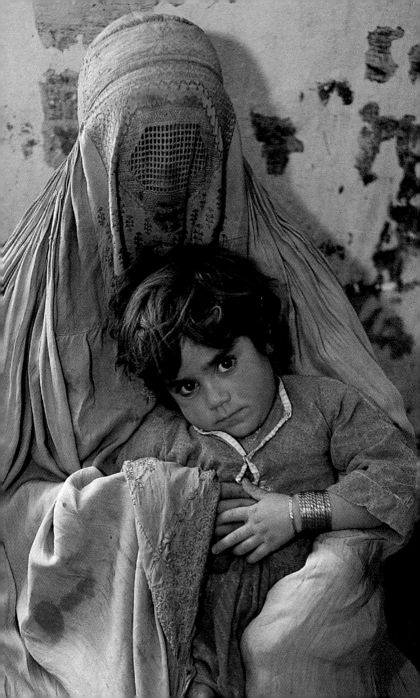

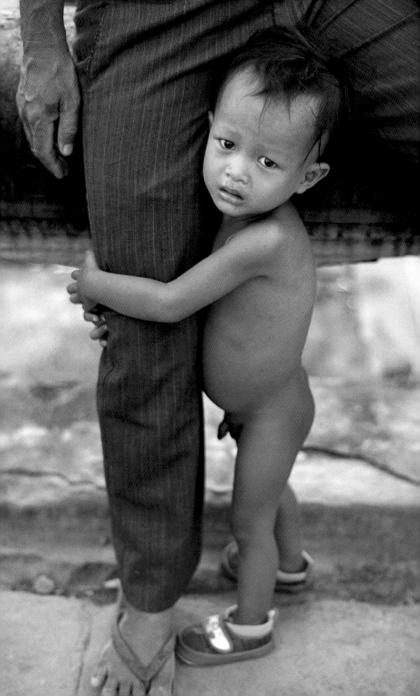

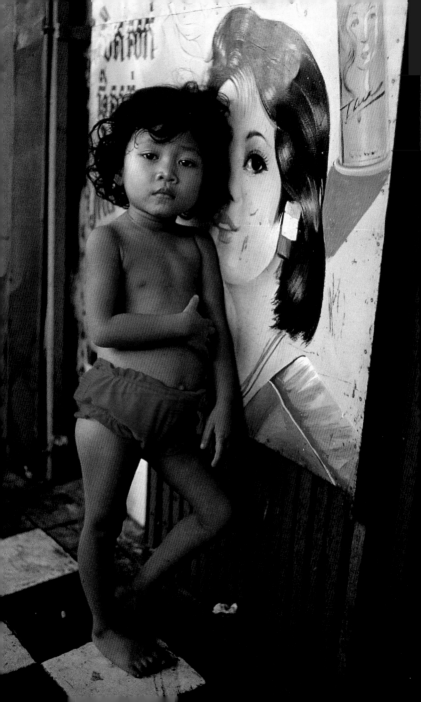

Al Ahmadi, Kuwait, 1991

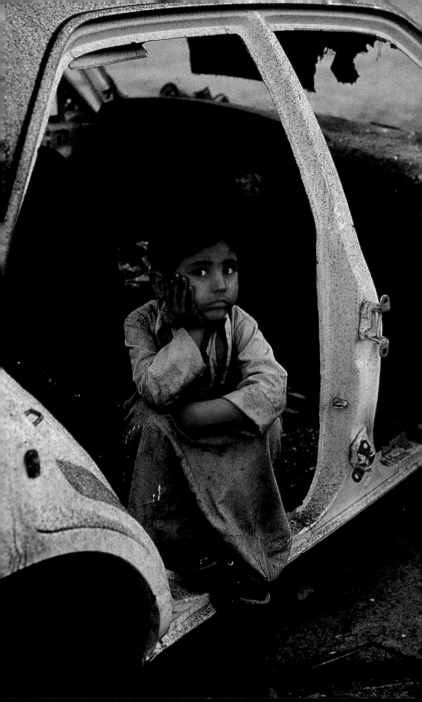

Sikkim, India, 1998

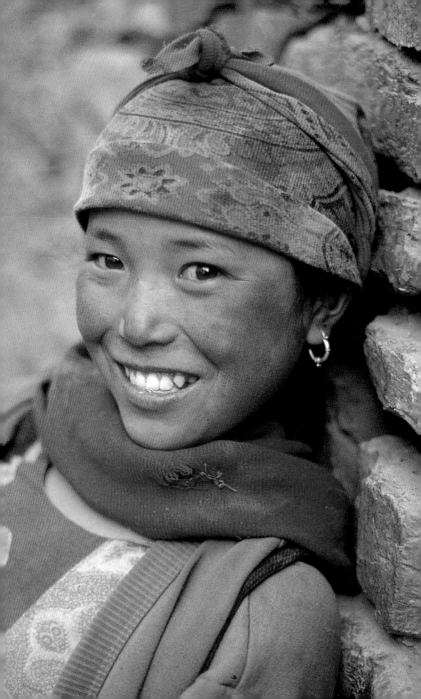

Manang, Nepal, 1998

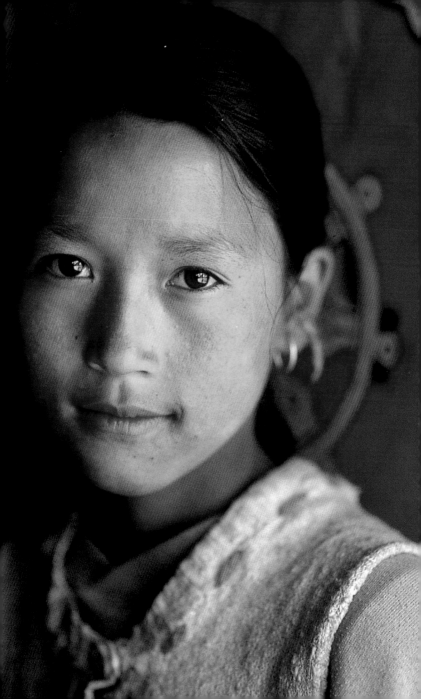

Rangoon, Burma, 1995

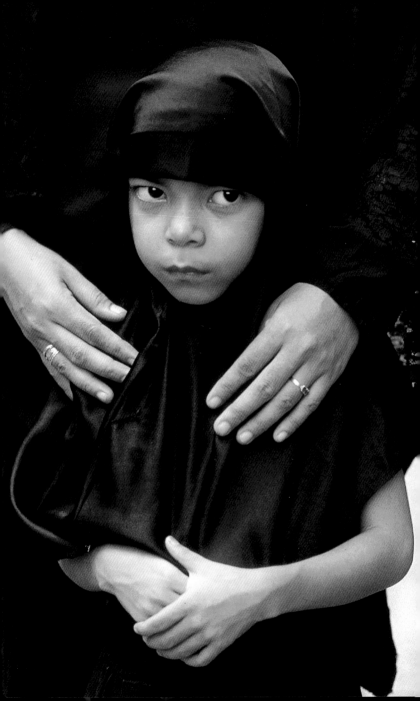

Sikkim, India, 1996

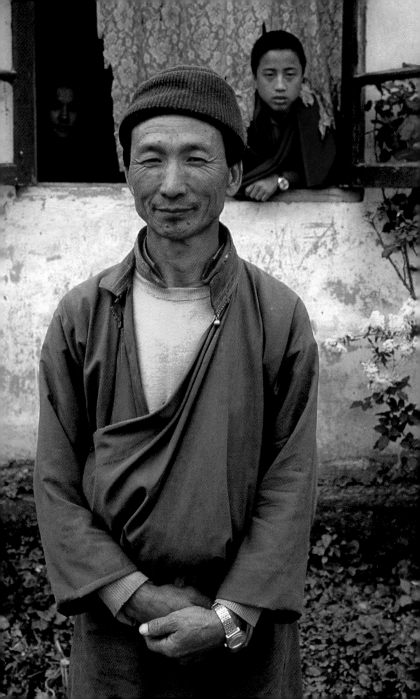

Zagreb, Croatia, 1989

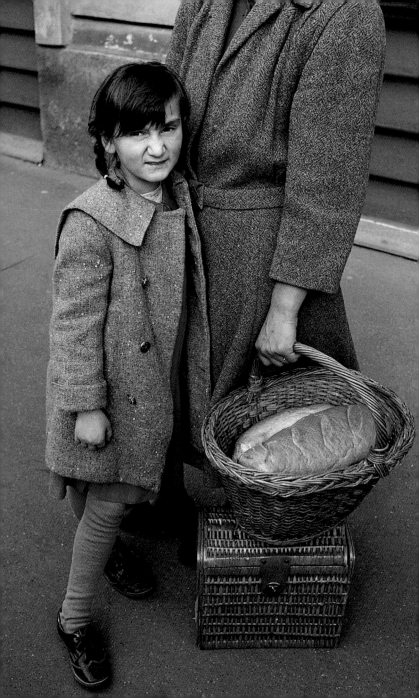

Kathmandu Valley, Nepal, 1983

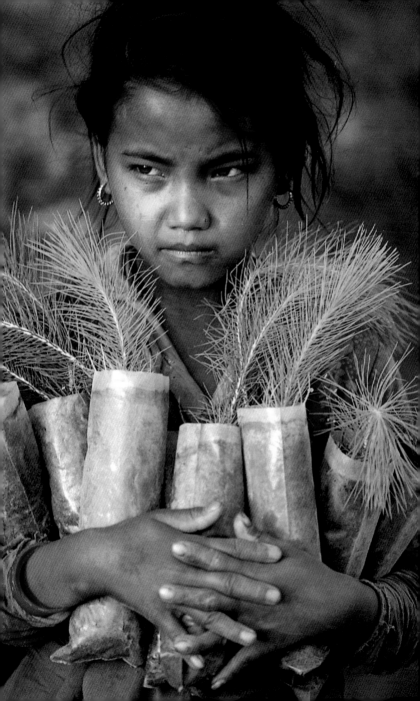

Timbuktu, Mali, 1986

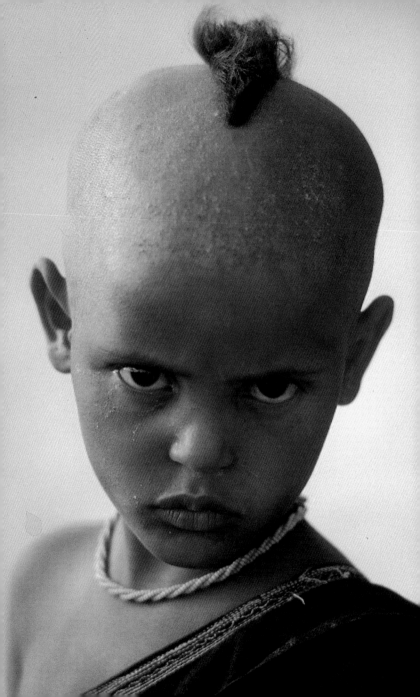

Hindu Kush mountains, Pakistan, 1980

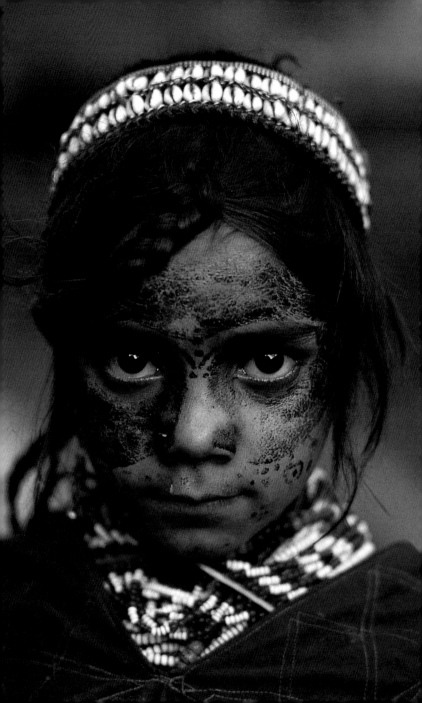

Rangoon, Burma, 1995

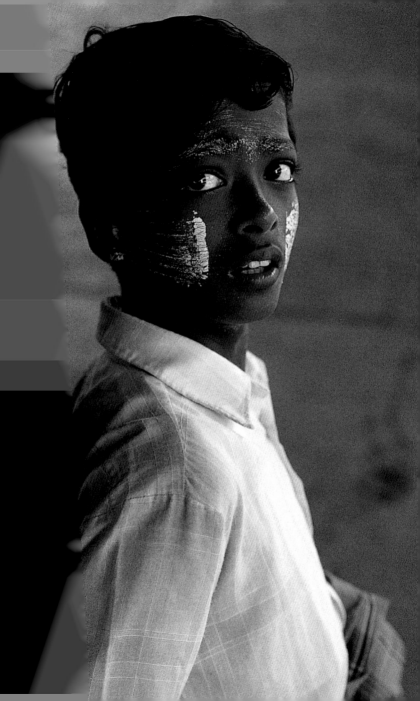

Ladakh, India, 1994

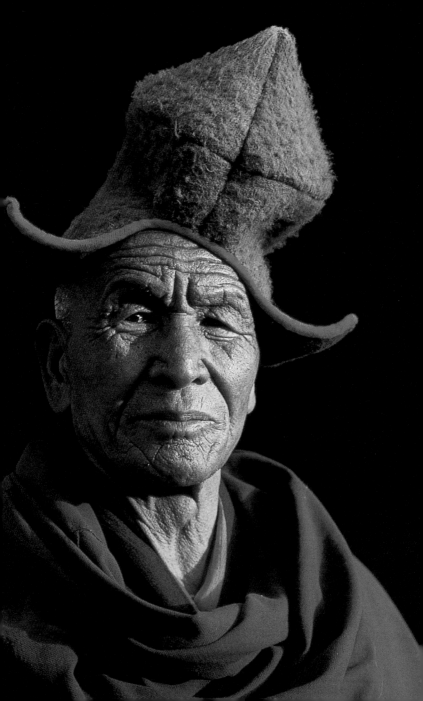

Rajasthan, India, 1983

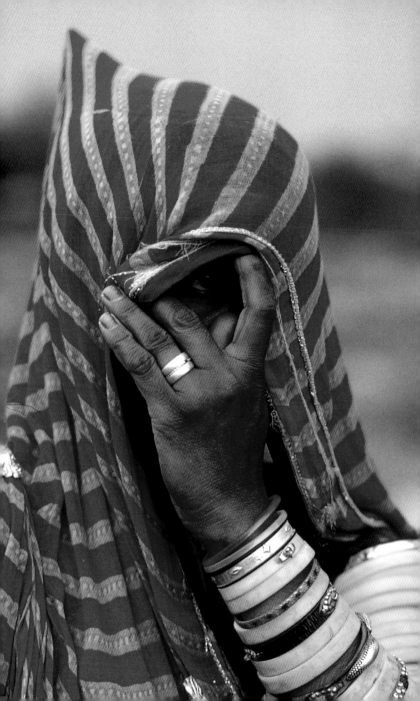

Haridwar, India, 1998

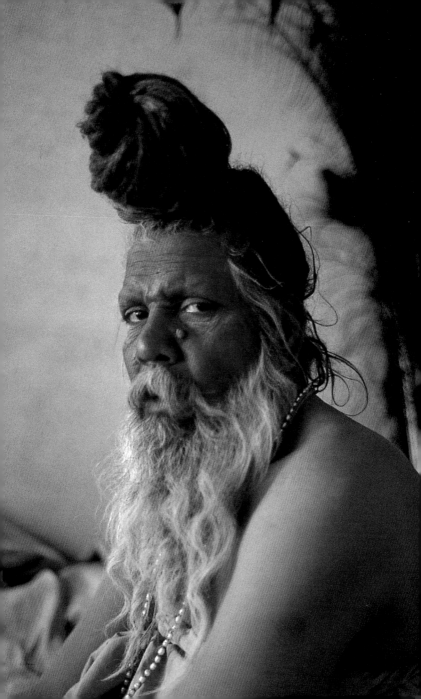

Amritsar, India, 1996

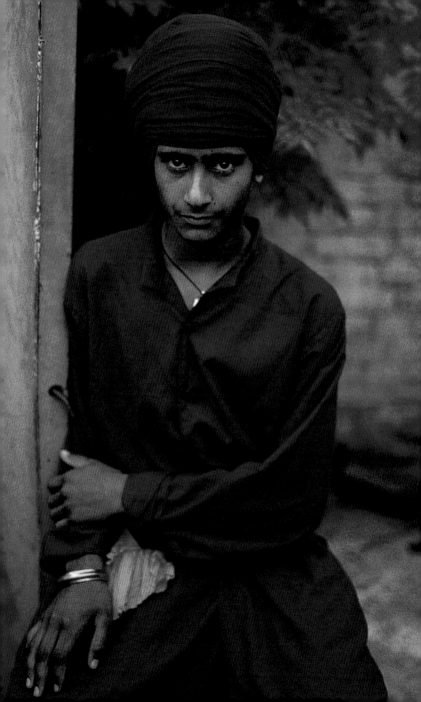

Nuwara Eliya, Sri Lanka, 1996

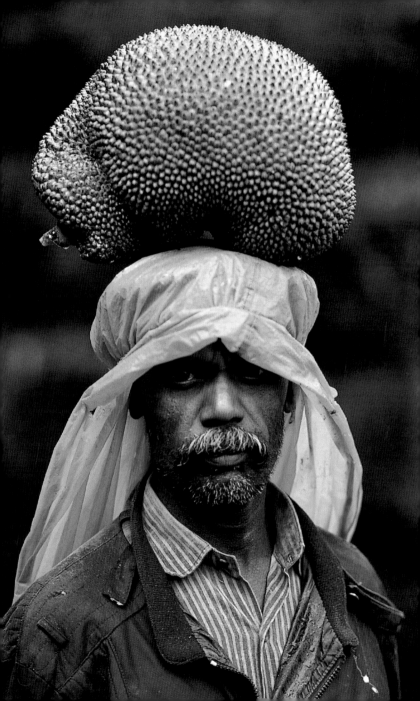

Shanghai, China, 1989

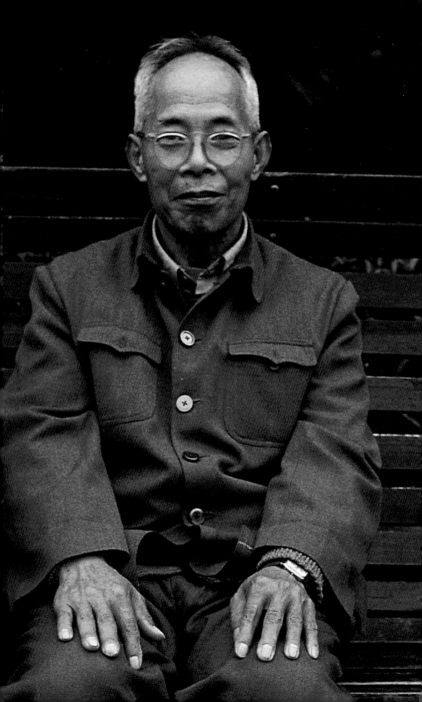

Filadelfia, Paraguay, 1986

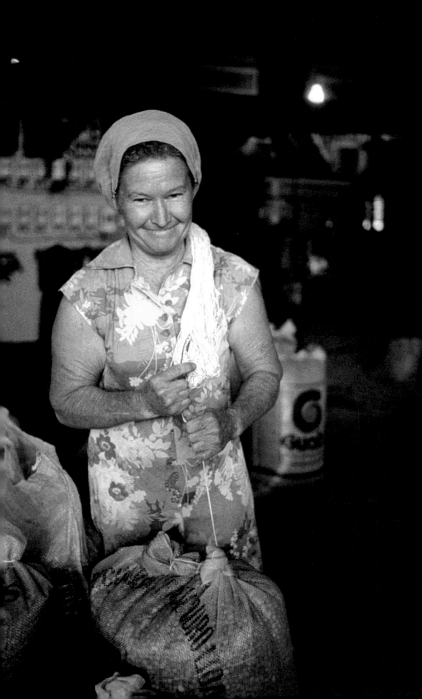

Porbandar, India, 1983

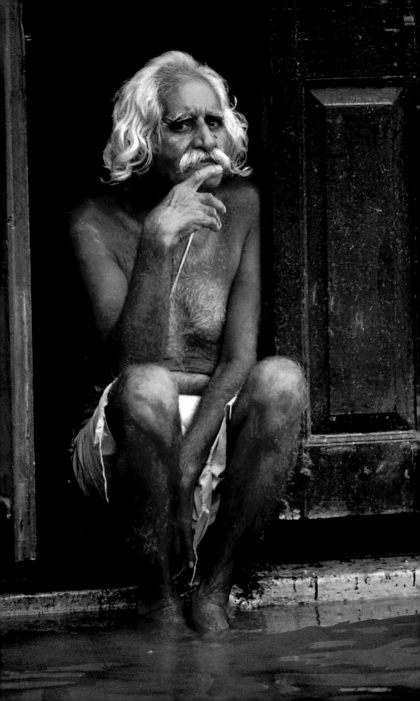

Varanasi, India, 1996

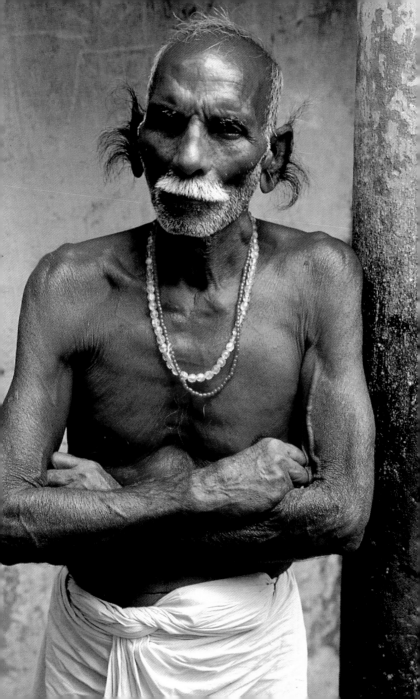

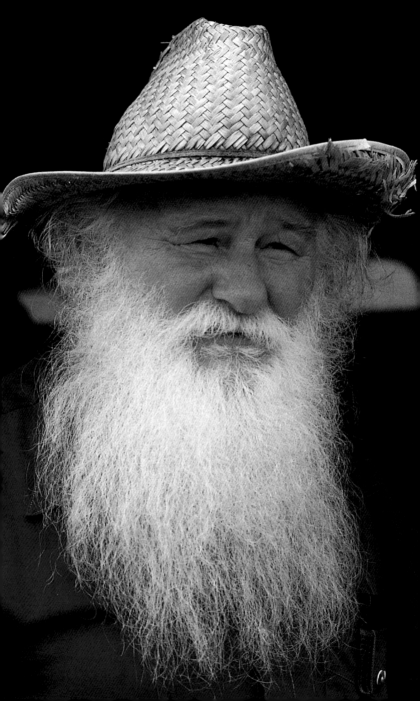

Kahan, Pakistan, 1980

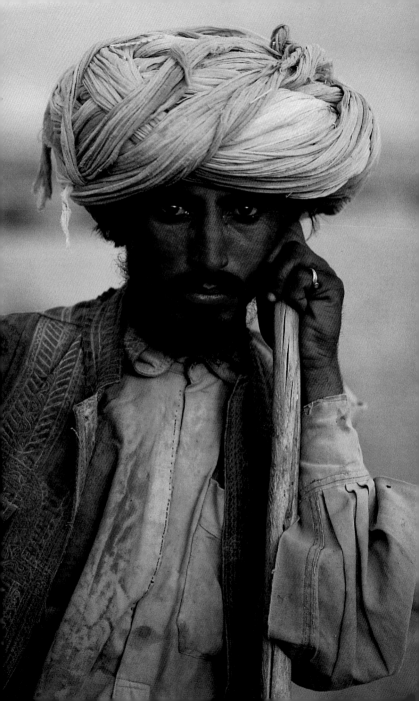

Baluchistan, Pakistan, 1980

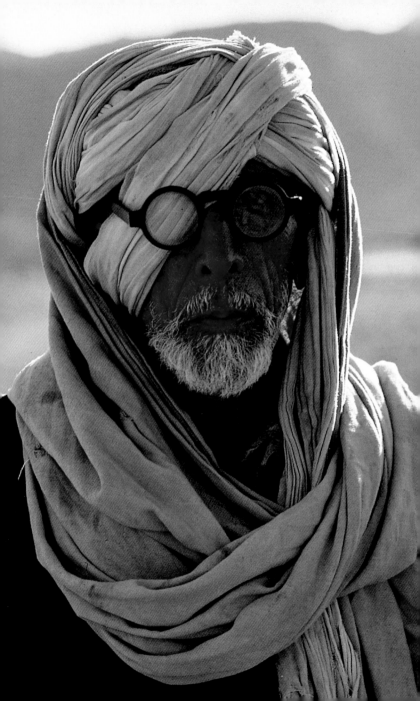

Madras, India, 1983

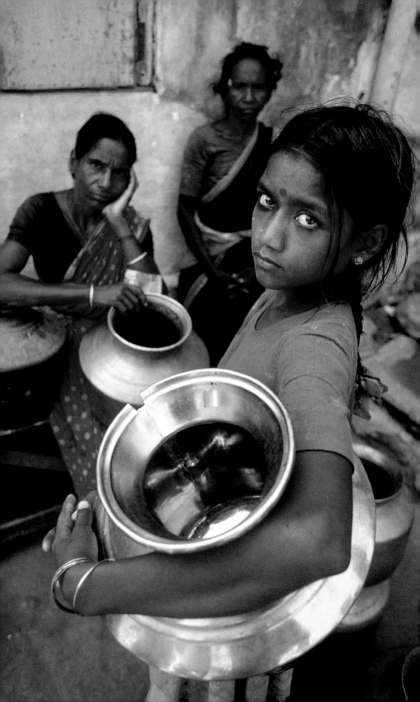

Bombay, India, 1993

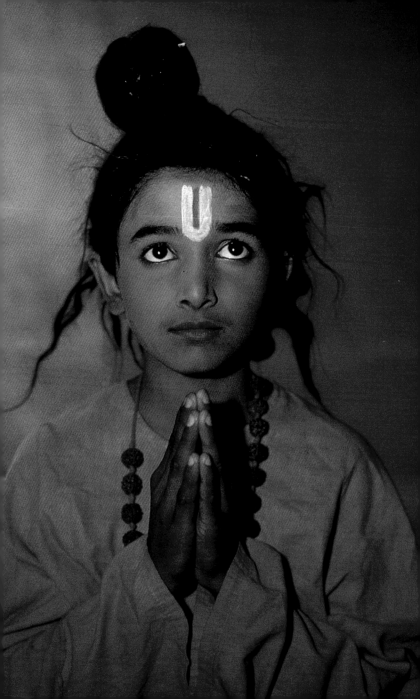

Angkor Wat, Cambodia, 1986

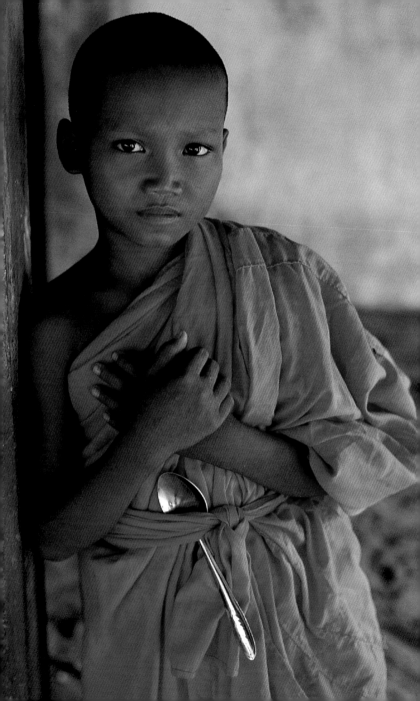

East Germany, 1989

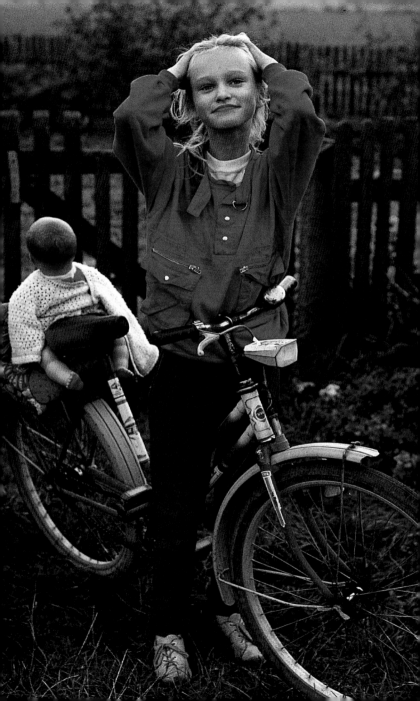

Haridwar, India, 1998

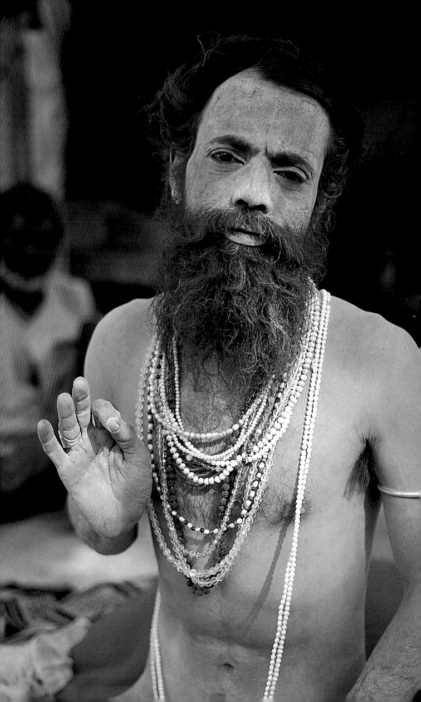

Landi Kotal, Pakistan, 1983

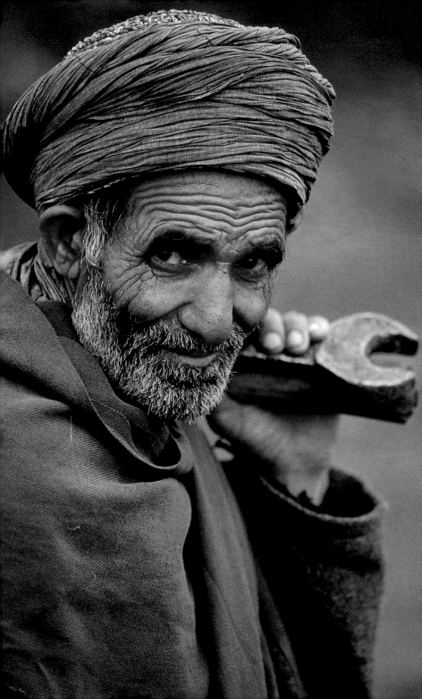

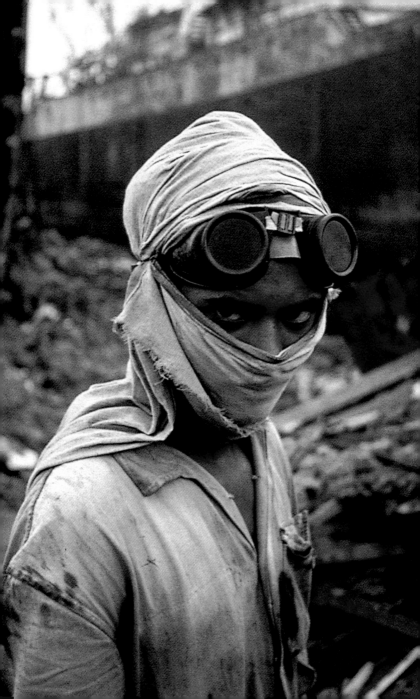

Mindanao, Philippines, 1985

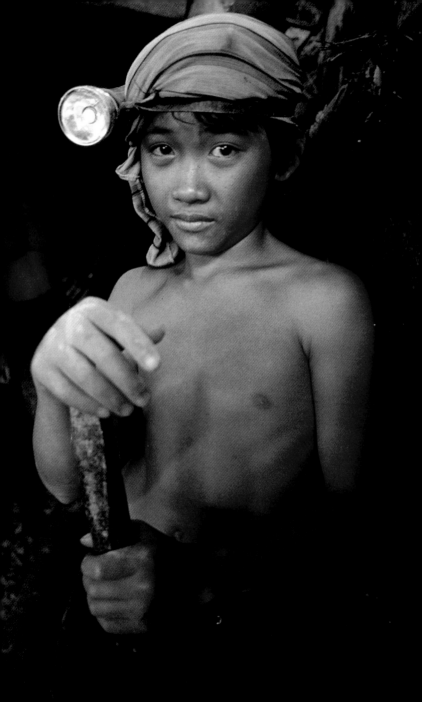

Pol-e Khomri, Afghanistan, 1993

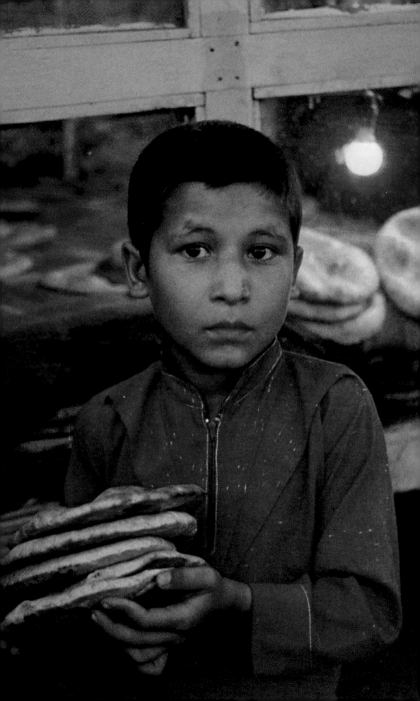

Montenegro, Yugoslavia, 1988

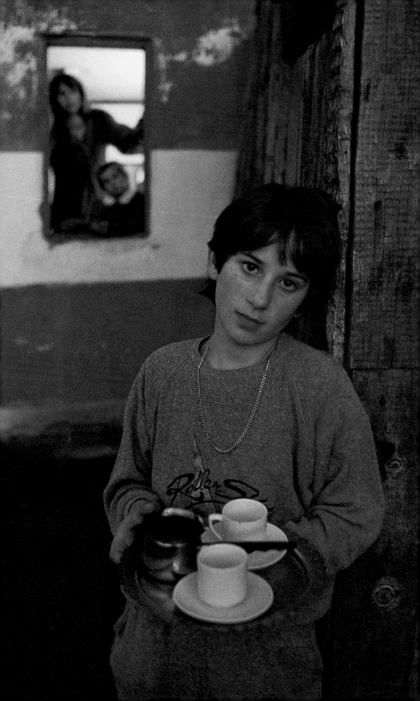

Phokhara, Nepal, 1984

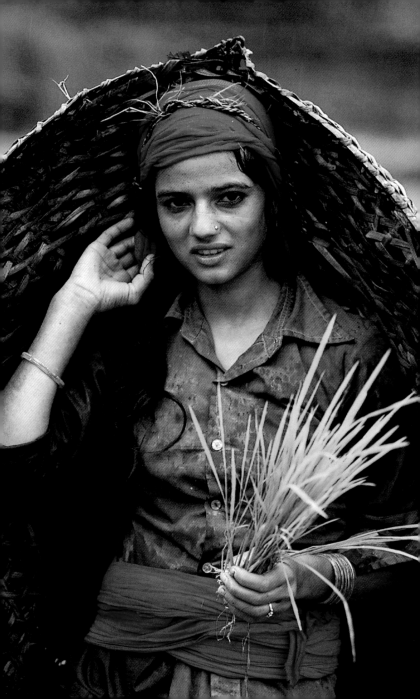

Madhya Pradesh, India, 1996

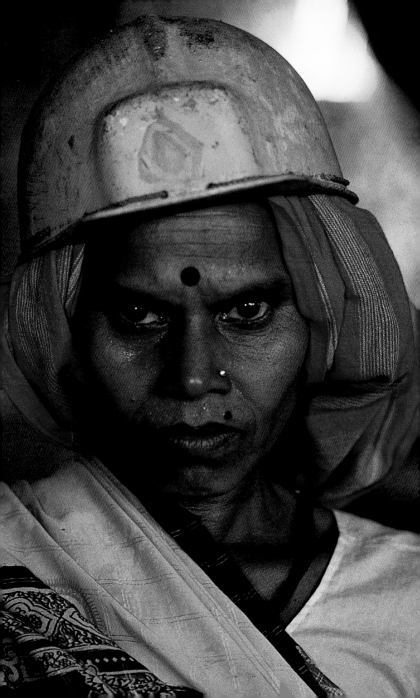

Chaco, Paraguay, 1986

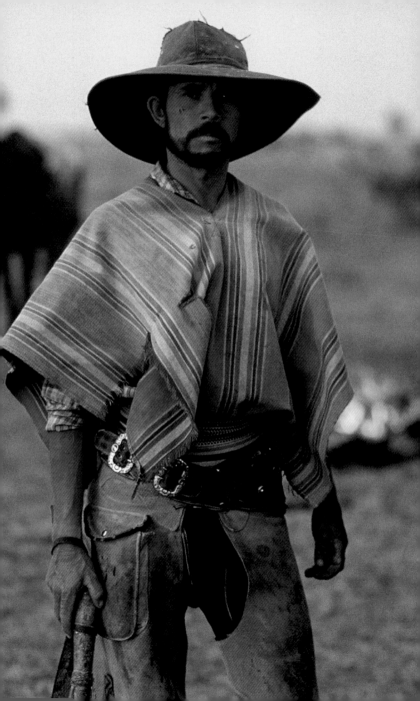

Kabul, Afghanistan, 1992

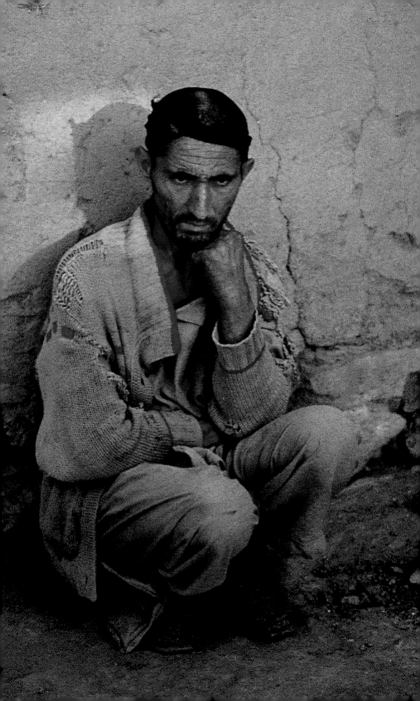

Marpha, Nepal, 1998

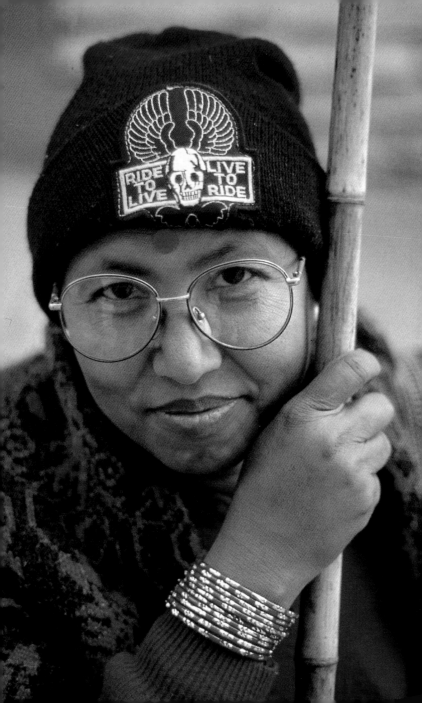

Tahoua, Niger, 1986

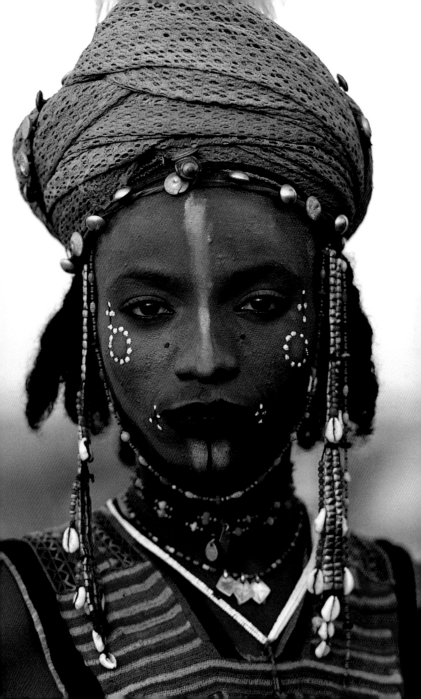

Los Angeles, USA, 1991

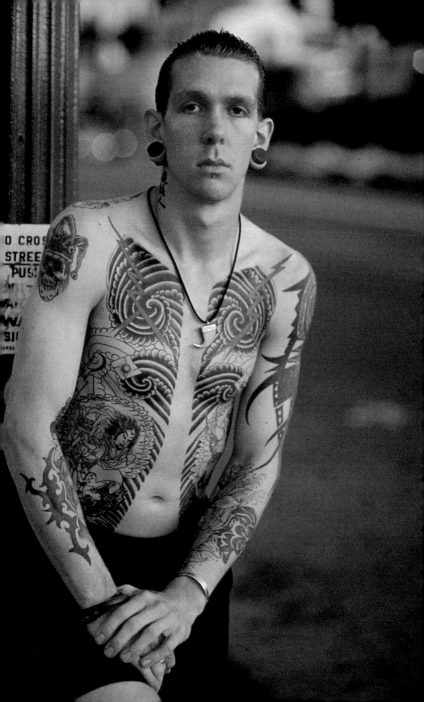

Luzon, Philippines, 1985

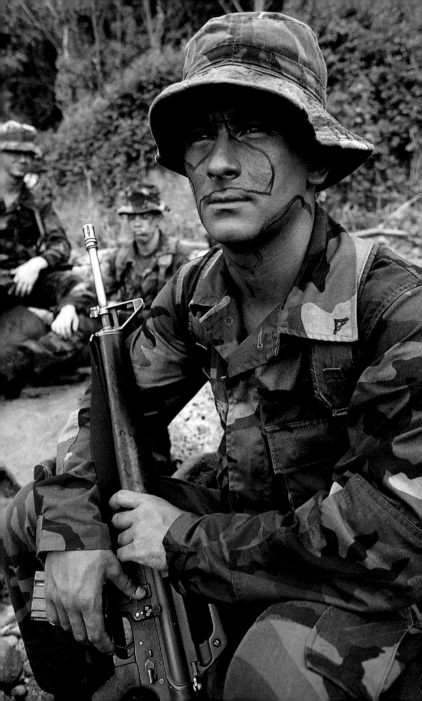

Jalalabad, Afghanistan, 1988

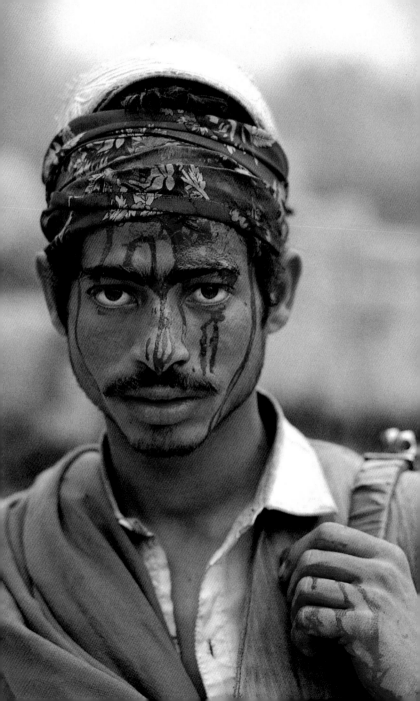

Kabul, Afghanistan, 1992

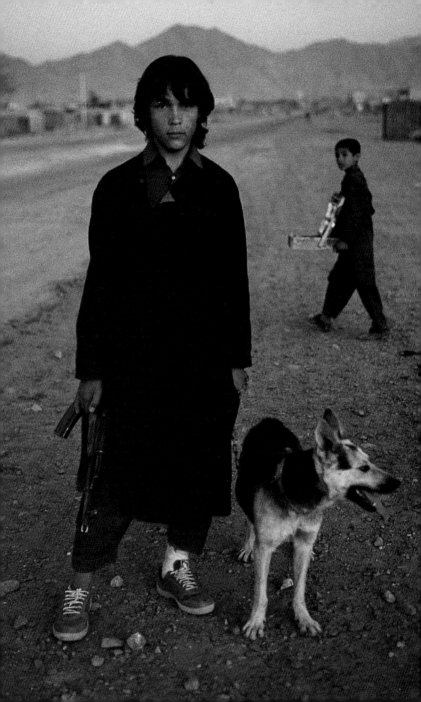

Kabul, Afghanistan, 1992

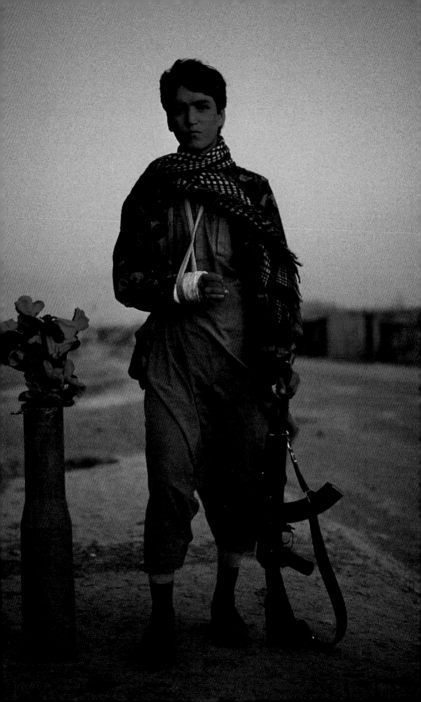

Luzon, Philippines, 1986

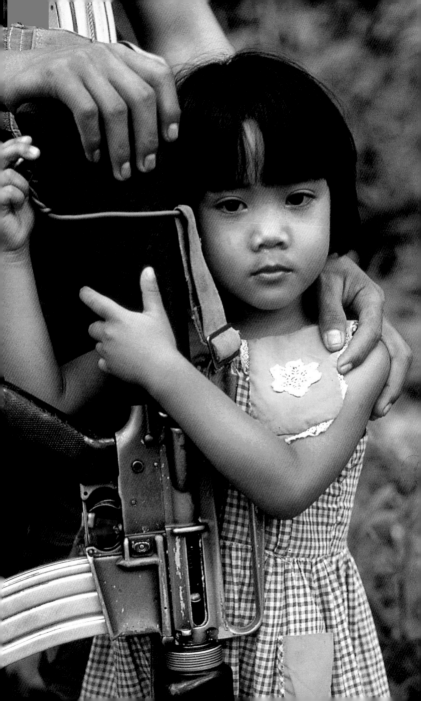

Batticaloa, Sri Lanka, 1995

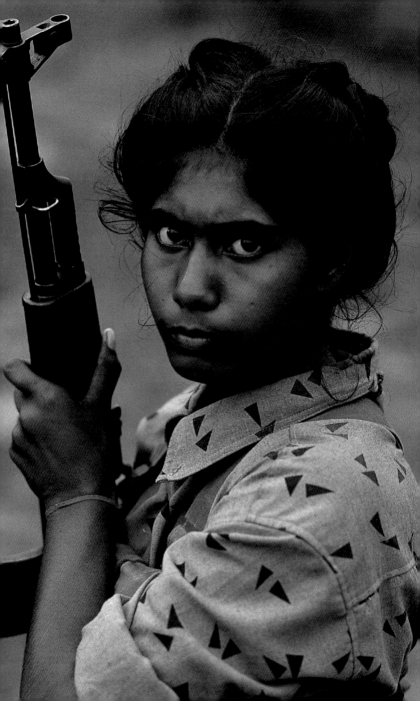

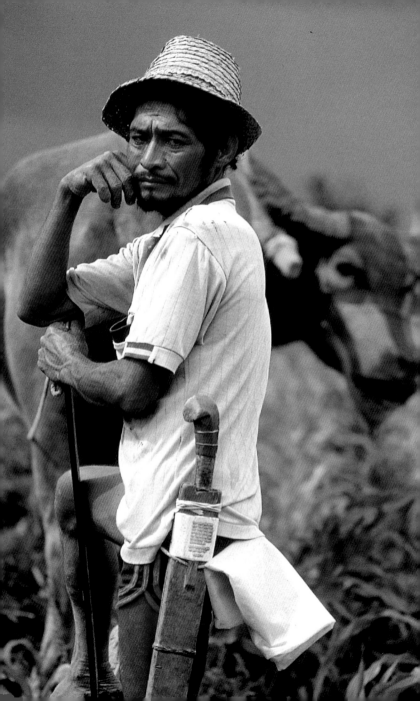

Pago, Burma, 1995

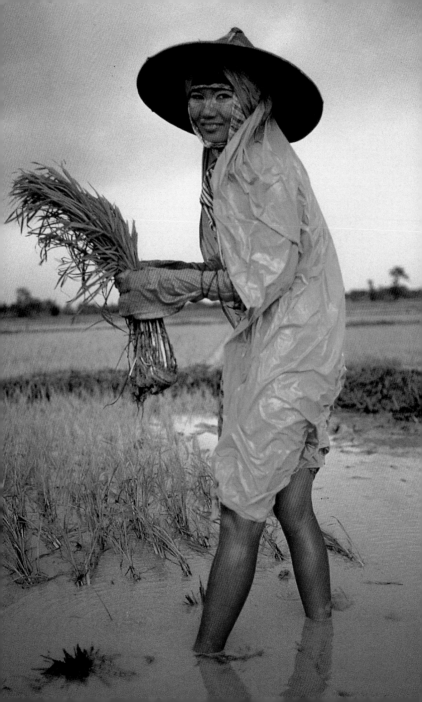

Timbuktu, Mali, 1985

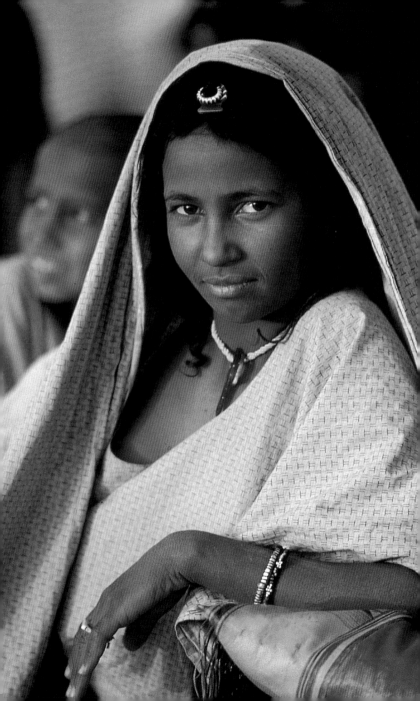

Phnom Penh, Cambodia, 1986

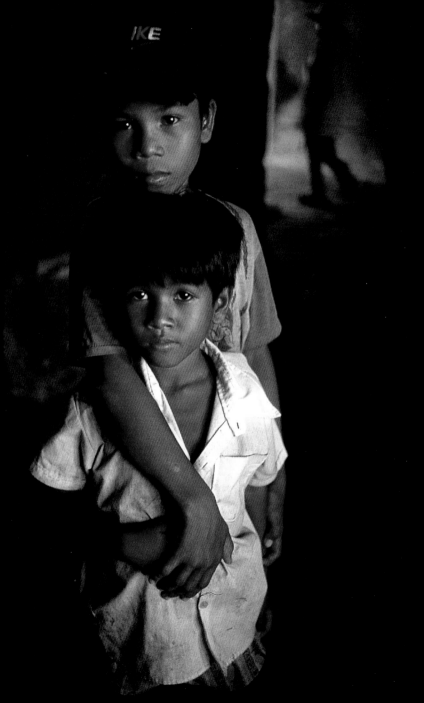

Xigaze, Tibet, 1989

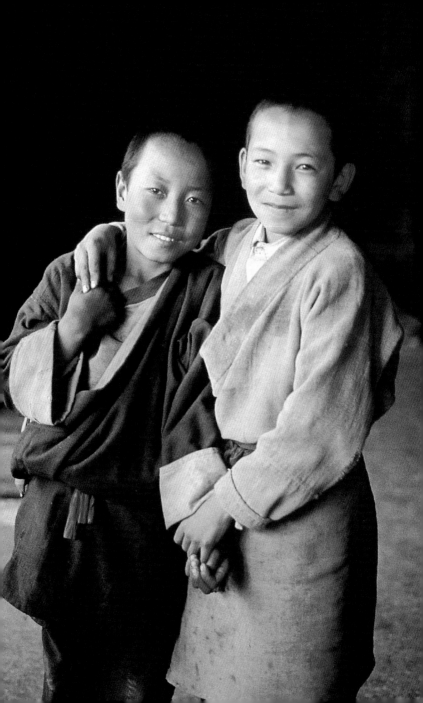

Shanghai, China, 1989

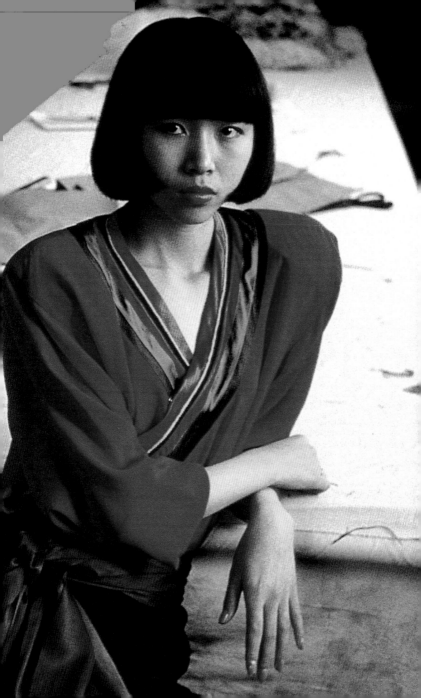

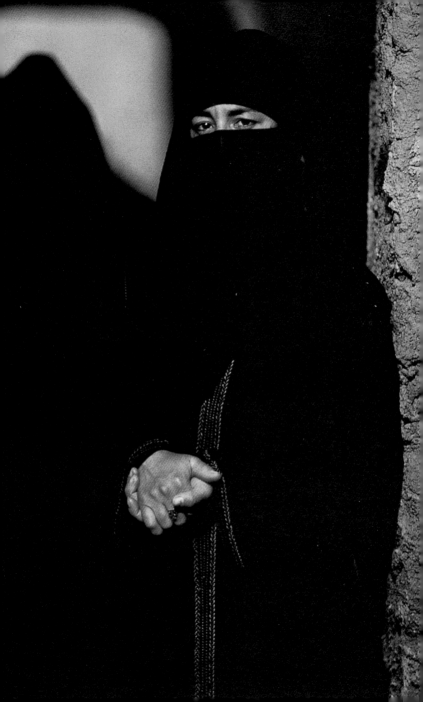

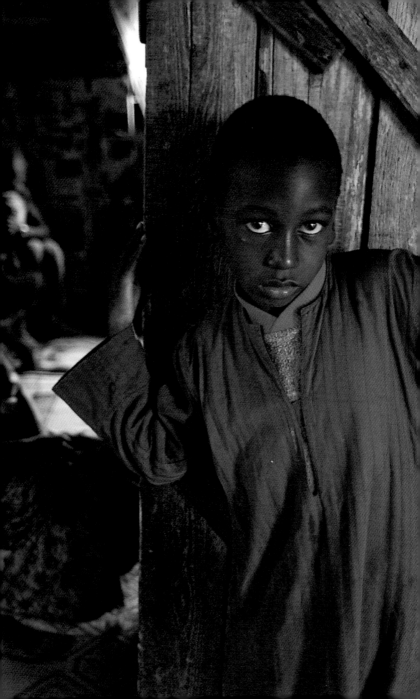

Gao, Mali, 1985

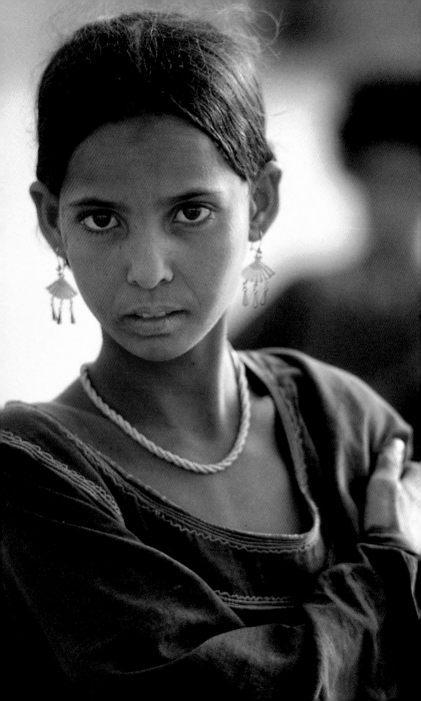

Lake Chad, Chad, 1986

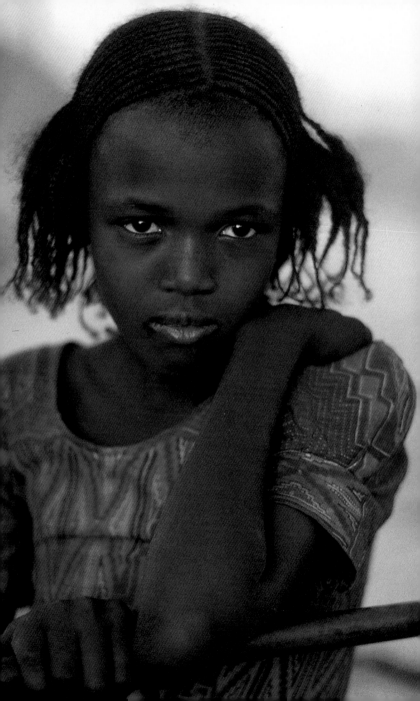

St. Louis, Senegal, 1985

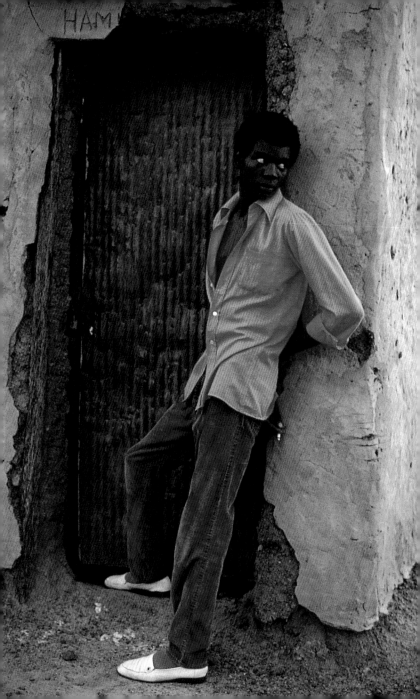

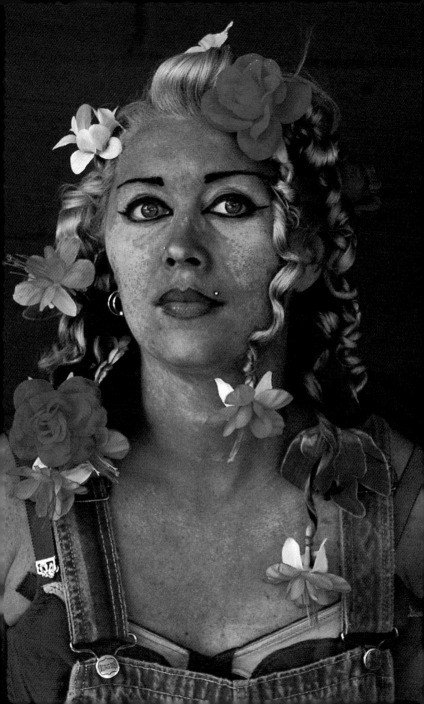

Marseilles, France, 1989

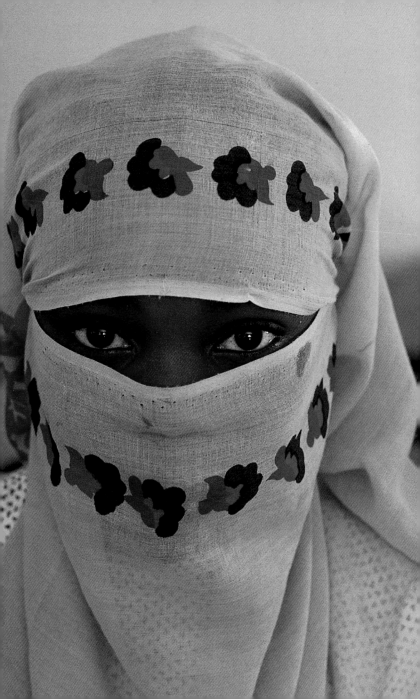

Manang, Nepal, 1998

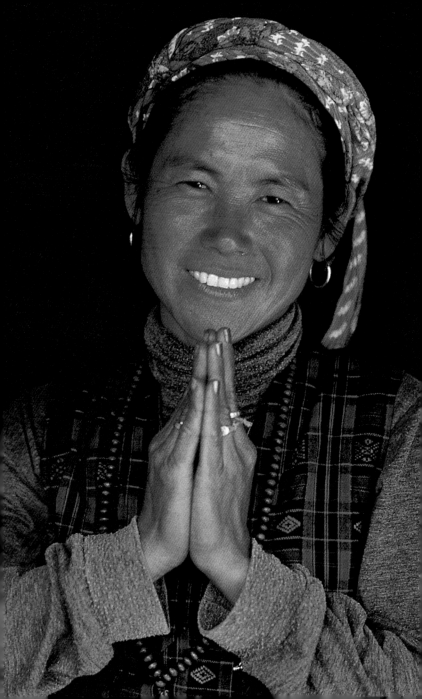

Rangoon, Burma, 1995

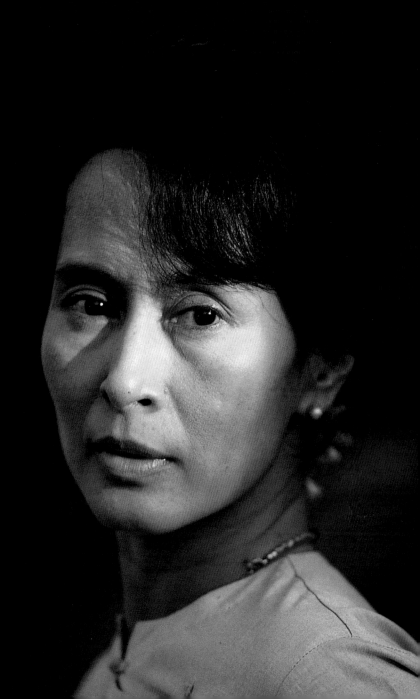

Jodhpur, India, 1980

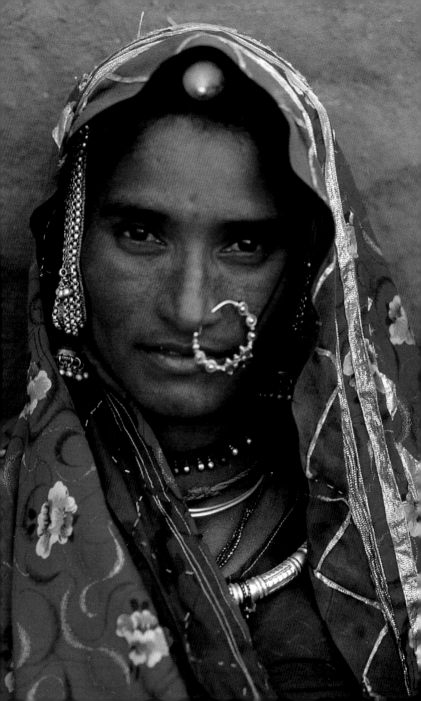

Haridwar, India, 1998

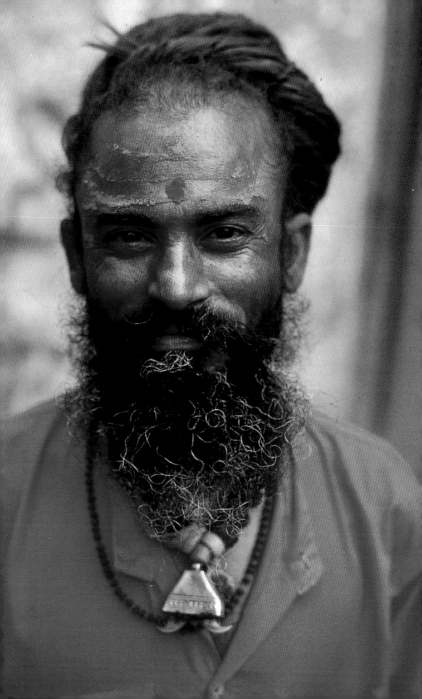

Basilan, Philippines, 1985

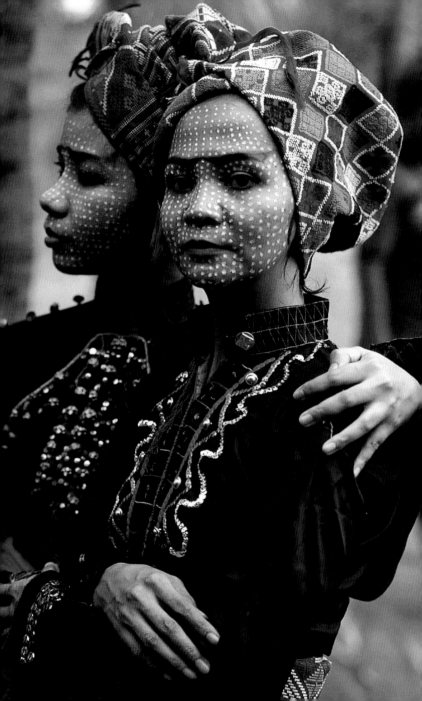

Lancaster, Pennsylvania, 1998

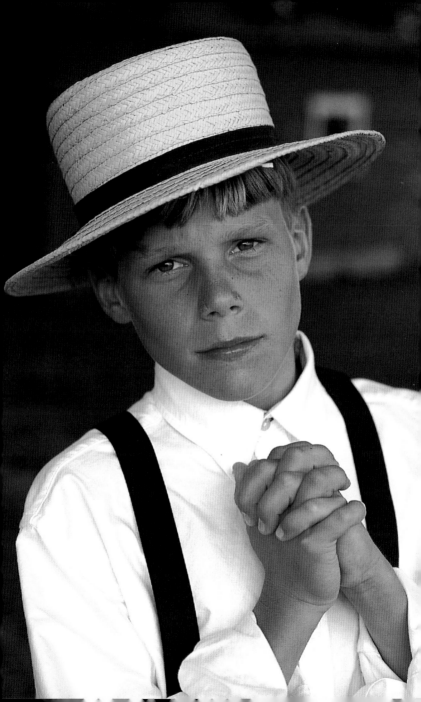

Herat, Afghanistan, 1990

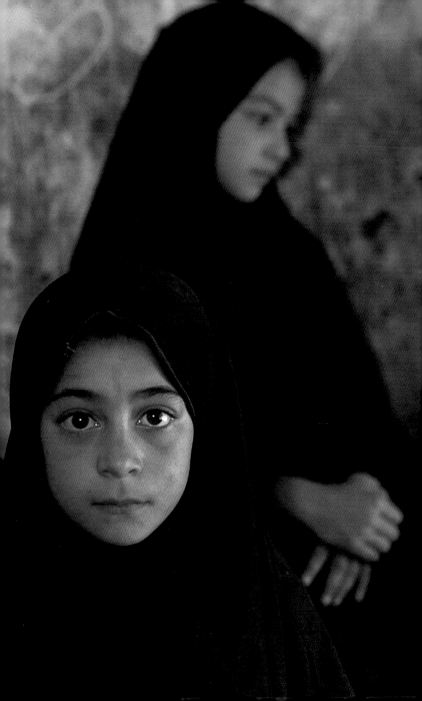

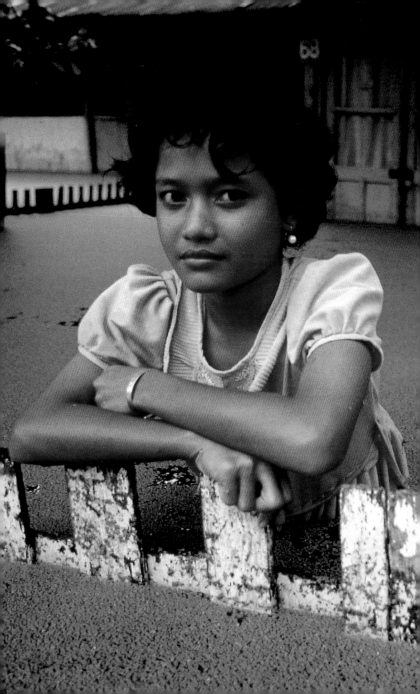

West Bengal, India, 1982

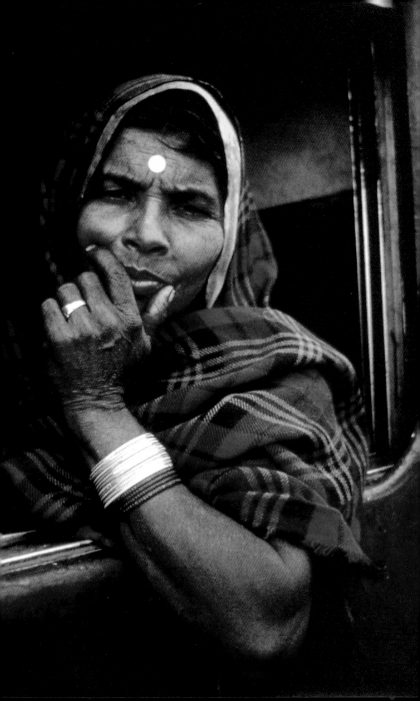

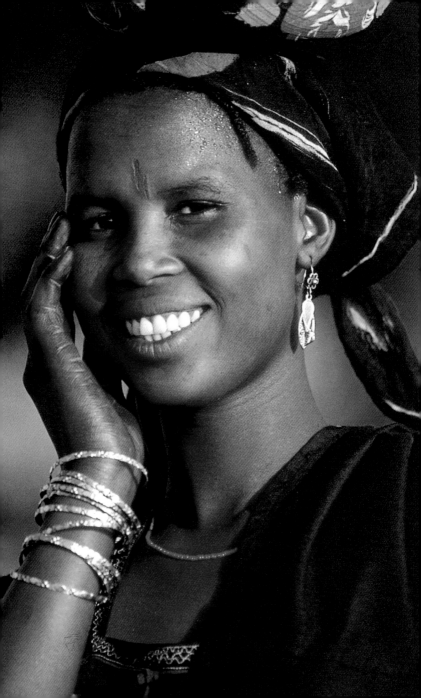

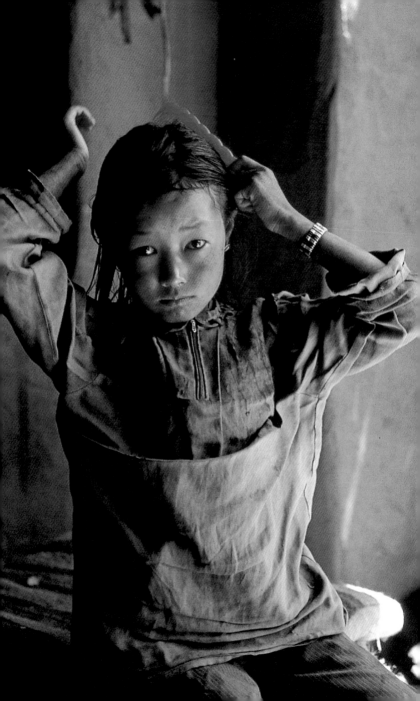

Xigaze, Tibet, 1989

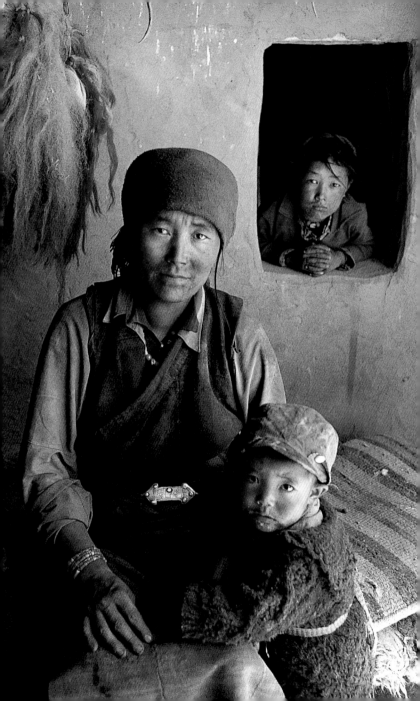

Kabul, Afghanistan, 1991

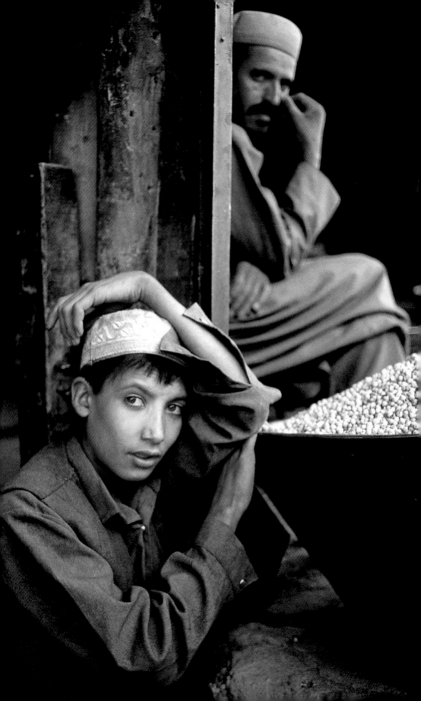

Jalalabad, Afghanistan, 1988

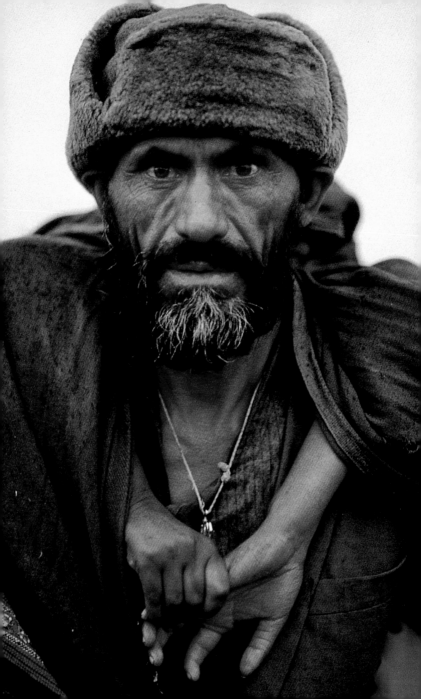

Haridwar, India, 1998

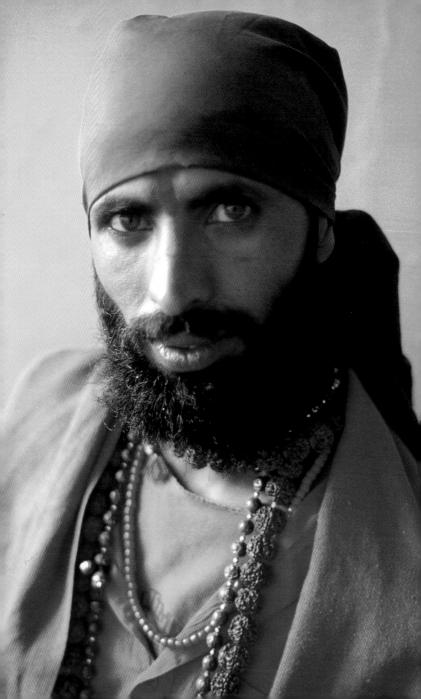

Bombay, India, 1983

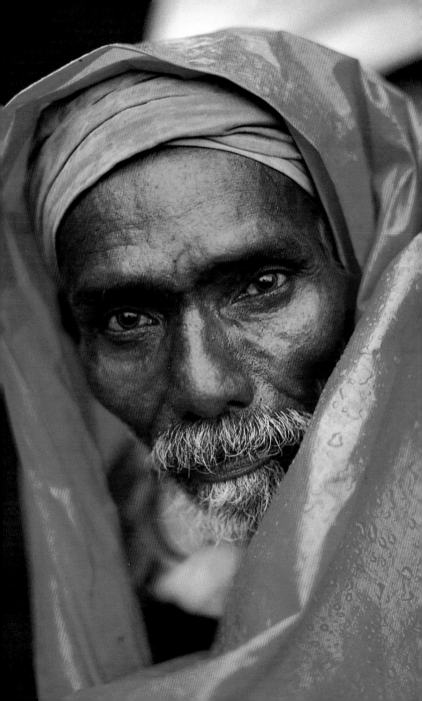

Pristina, Yugoslavia, 1998

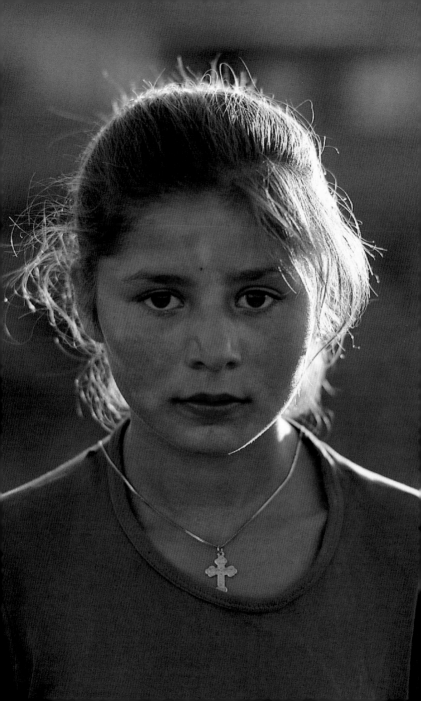

Tahoua, Niger, 1986

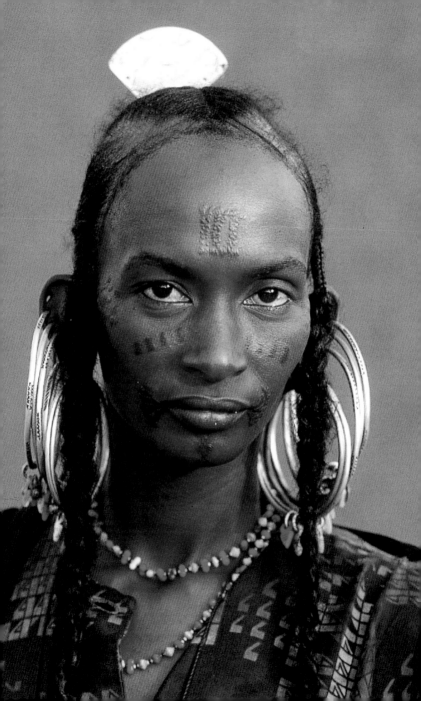

Mazar-e Sharif, Afghanistan, 1991

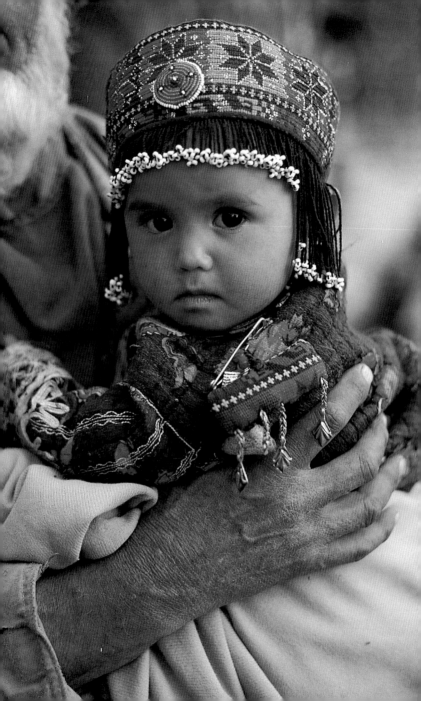

Pagan, Burma, 1995

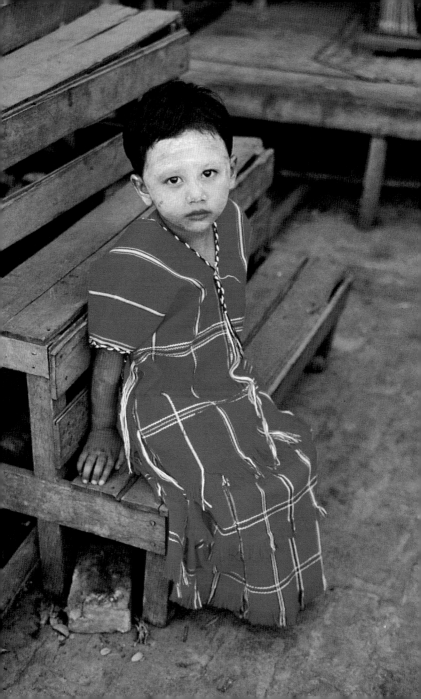

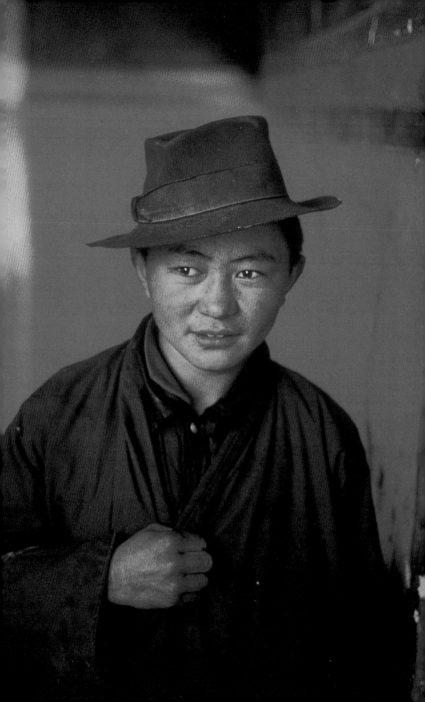

Rajasthan, India, 1997

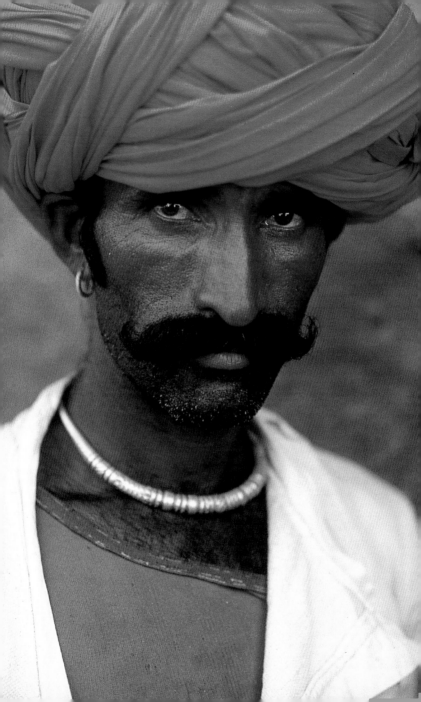

Rome, Italy, 1996

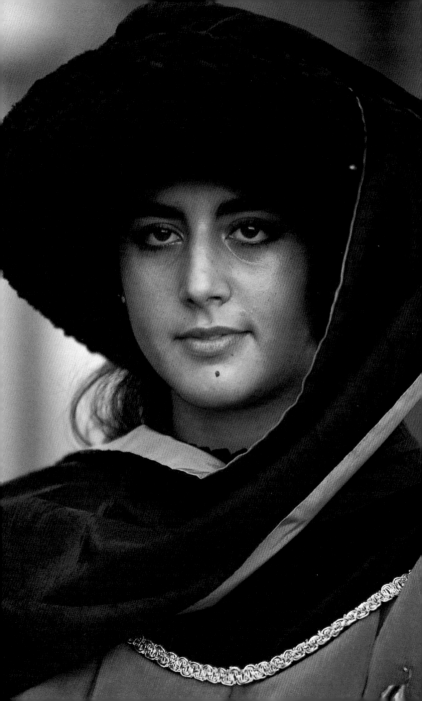

Ajmer, Rajasthan, 1983

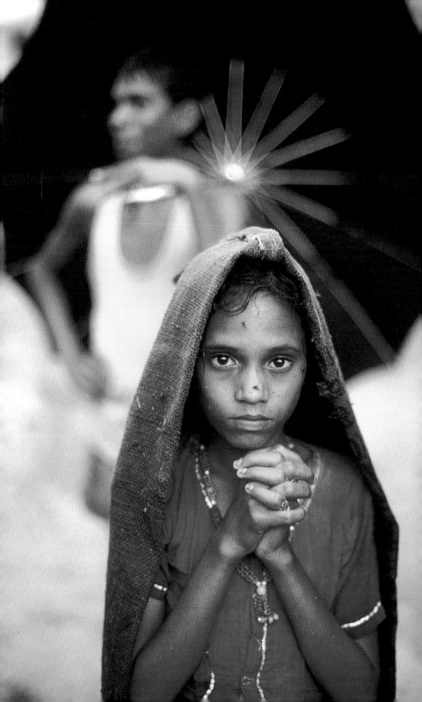

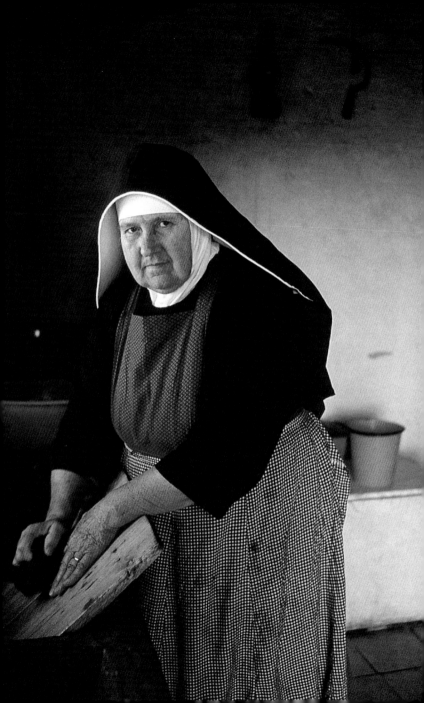

Los Angeles, USA, 1991

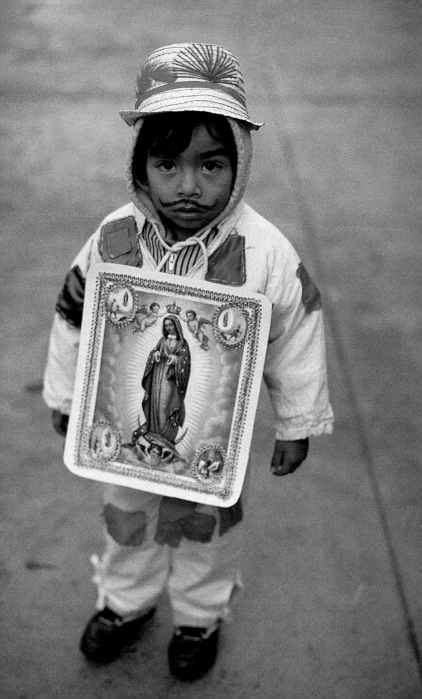

Haridwar, India, 1998

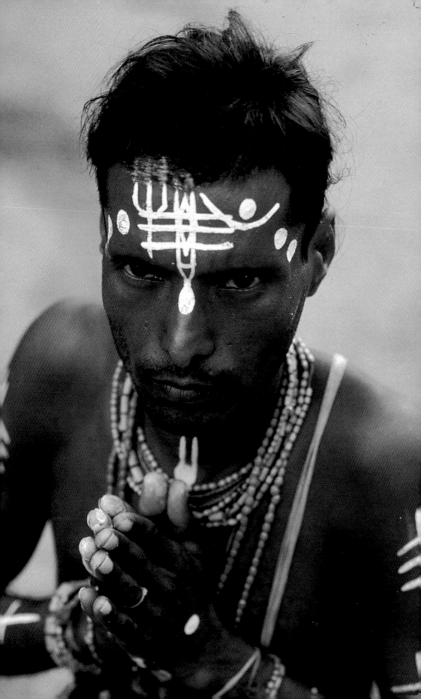

Rangoon, Burma, 1995

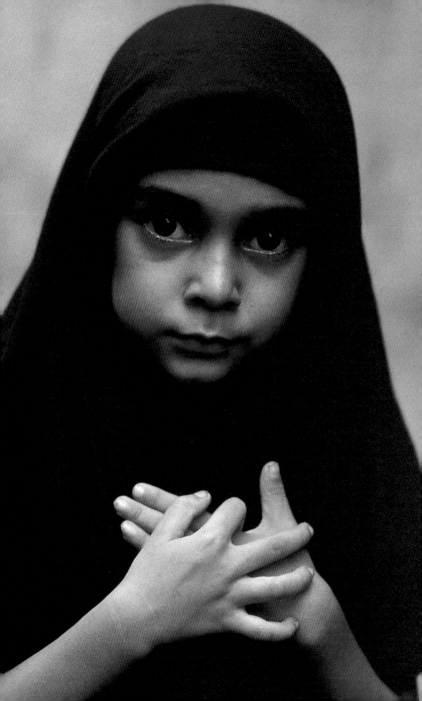

Mindanao, Philippines, 1985

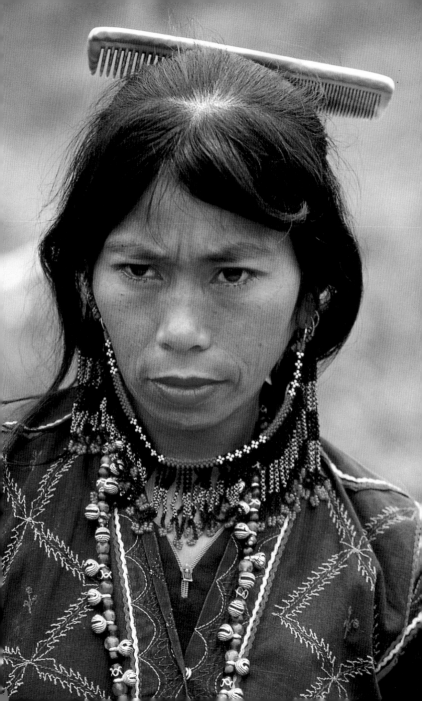

Bombay, India, 1994

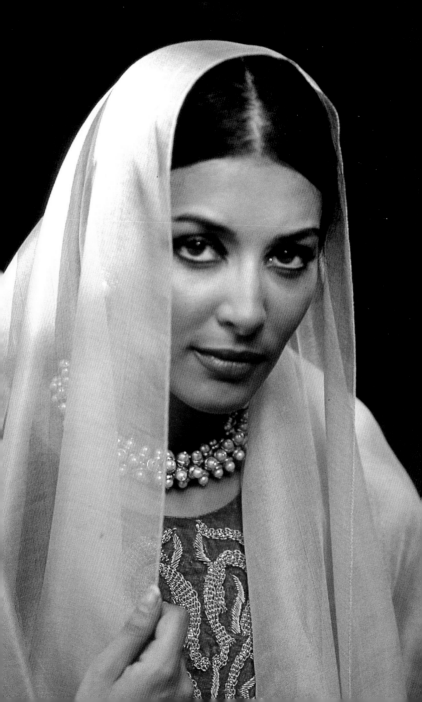

Rangoon, Burma, 1995

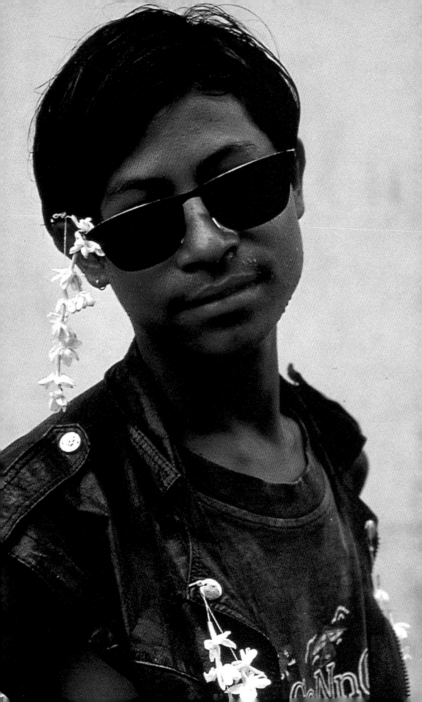

Chitral, Pakistan, 1980

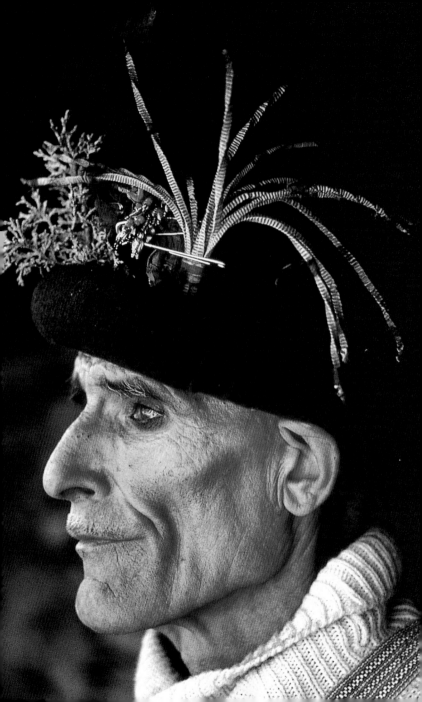

Loikaw, Burma, 1995

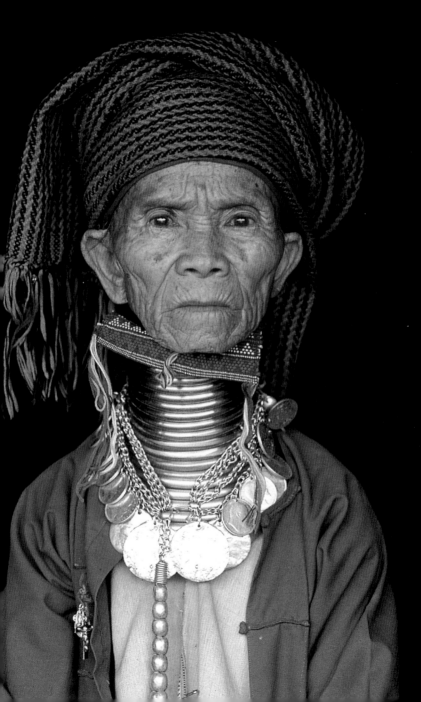

NDjamena, Chad, 1985

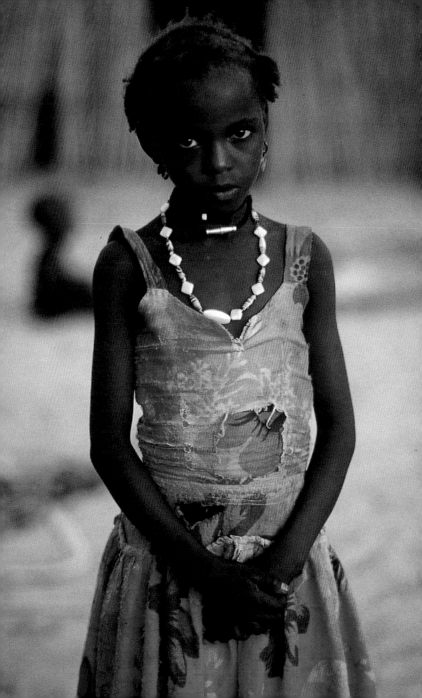

Rangoon, Burma, 1994

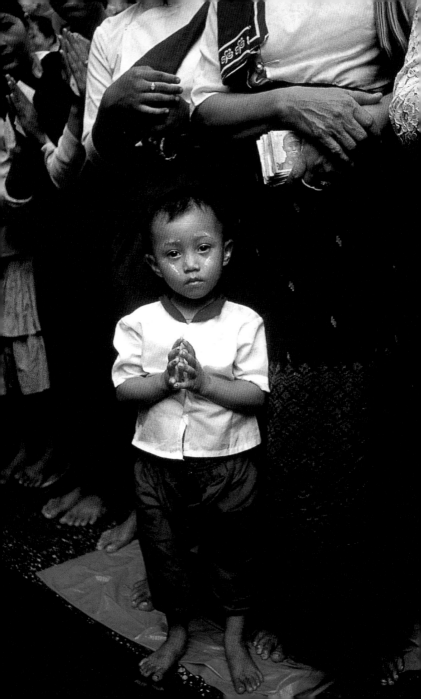

Kosovo, Yugoslavia, 1989

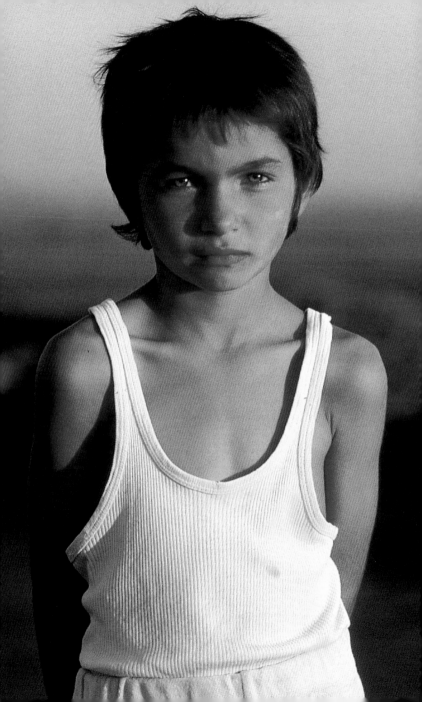

Phnom Penh, Cambodia, 1986

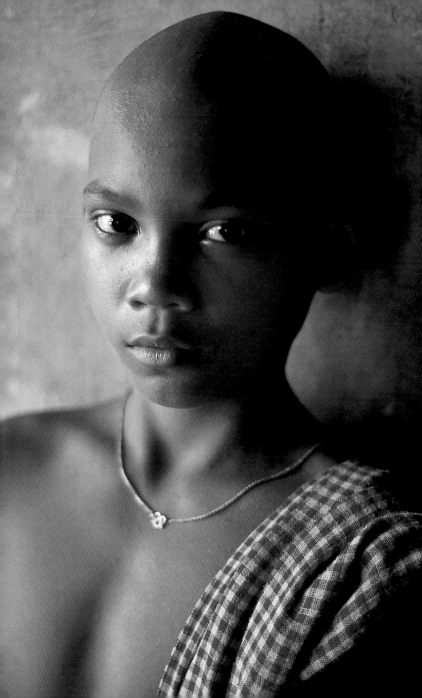

Chittagong, Bangladesh, 1983

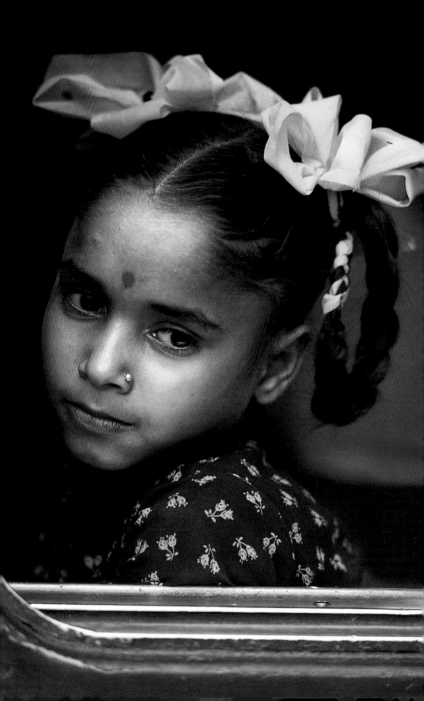

Nouakchott, Mauritania, 1985

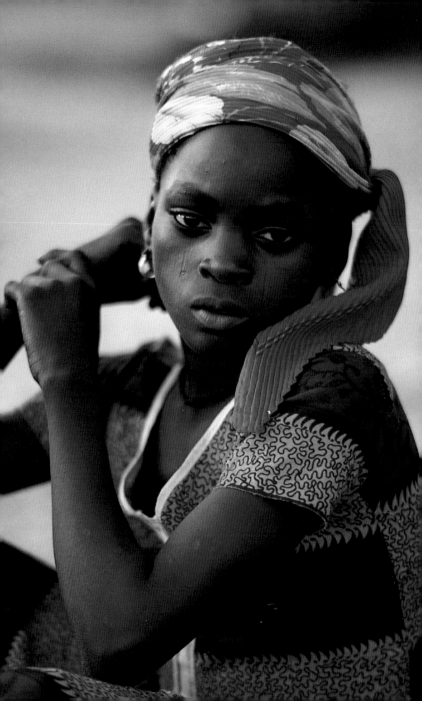

Gujarat, India, 1996

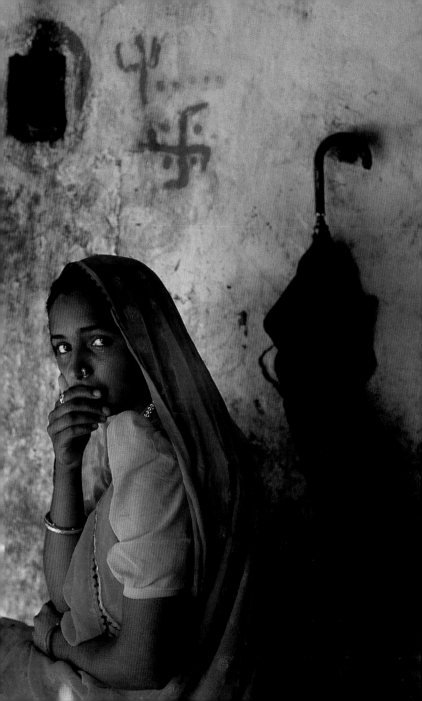

Rangoon, Burma, 1995

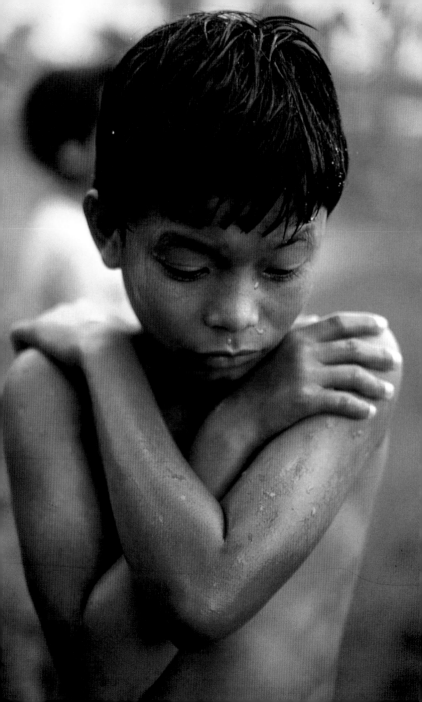

Steve McCurry has photographed for *National Geographic* for 20 years
and has been a member of the Magnum photo agency since 1990.
Critically acclaimed for his colour reportage, his portrait of the
Afghan girl, featured on the cover, has become one of contemporary
photography's most celebrated and best-known portraits. Steve has
won many prizes for his photo essays shot all over the world.
He lives in New York City.

The author would like to acknowledge and thank:
Bill Allen, Chris Boot, Jo Chapman, Rich Clarkson, Bob Dannin,
Arnold Drapkin, Bruce Duffy, John Echave, David Friend, Bill Garrett,
Bob Gilka, Bill Graves, Erich Hartmann, Tom Kennedy, Kent Kobersteen,
Bill Marr, Natasha Mitchell, Danielle Oum, Kathy Ryan,
Amanda Renshaw, Elie Rogers, Richard Schlagman, Karl Shanahan,
Michele Stephenson, Robert Stevens, Amanda Tétrault and Paul Theroux

COVER: Pakistan, 1985

Phaidon Press Limited
Regent's Wharf
All Saints Street
London N1 9PA

Phaidon Press Inc.
180 Varick Street
New York
NY 10014

www.phaidon.com

First published 1999
Reprinted 1999, 2000 (twice), 2001 (twice)
© 1999 Phaidon Press Limited
Photographs © 1999 Steve McCurry

ISBN 07148 3839 X

A CIP record for this book is available from the British Library

Printed and bound in Spain